FACING THE FINISH

Some Recent California Art

Initiated and principally supported by the
Fellows of Contemporary Art, Los Angeles

Organized by the
San Francisco Museum of Modern Art

This publication was produced in conjunction with the exhibition *Facing the Finish: Some Recent California Art,* initiated and principally supported by the Fellows of Contemporary Art, Los Angeles, and organized by the San Francisco Museum of Modern Art. *Facing the Finish* is part of the Museum's *New Work* series, which is generously supported by SFMOMA's Collectors Forum. Exhibition tour: Santa Barbara Contemporary Arts Forum, June 29–August 17, 1991; San Francisco Museum of Modern Art, September 20–December 1, 1991; Art Center College of Design, Pasadena, spring 1992.

Library of Congress Catalog Card Number: 91-72748
ISBN 0-911291-18-0

The San Francisco Museum of Modern Art is a privately funded, member-supported museum receiving major support from Grants for the Arts of the San Francisco Hotel Tax Fund and the National Endowment for the Arts, a Federal agency.

EDITOR: Kara Kirk
DESIGNER: Robin Weiss
TYPOGRAPHY: On Line Typography
PRINTER: Paragraphics

PHOTO CREDITS
In some instances the illustrations in this catalogue were supplied by the artist or by the owner of the work named on the checklist. Additional credits for the illustrations are listed here. P. 21: courtesy Jay Gorney Modern Art, New York; pps. 20, 22, 23, 27, 29, 30, 35, and 38: Wayne McCall, photographer; p. 26: James Franklin, photographer; p. 28: courtesy Shoshana Wayne Gallery, Los Angeles; p. 32: courtesy Thomas Solomon's Garage, Los Angeles; p. 33: Ben Blackwell, photographer; p. 34: courtesy Burnett Miller Gallery, Los Angeles; pps. 36 and 37: courtesy Luhring Augustine Gallery, New York.

CONTENTS

LENDERS TO THE EXHIBITION

Nayland Blake, San Francisco
Rena Bransten Gallery, San Francisco
Jerome Caja, San Francisco
John and Bernardine Caja, Lakewood, Ohio
Jim Campbell, San Francisco
Eileen and Michael Cohen, New York
Jeffrey Deitch, New York
The Rene and Veronica di Rosa Foundation, Napa
Jay Gorney, New York
Morris and Ellen Grabie, Los Angeles
Christian Huygen, San Francisco
David Kremers, Los Angeles
Pablo and Leslie Lawner, Los Angeles
Luhring Augustine Gallery, New York
Luhring Augustine Hetzler, Santa Monica
Lockhart Collection, New York
Robert Lue, Boston
James A. Luna, La Jolla Indian Reservation
Rena McDonald aka Adam Klein, San Francisco
Meyers/Bloom Gallery, Santa Monica
Burnett Miller Gallery, Los Angeles
Mincher/Wilcox Gallery, San Francisco
Jorge Pardo, Pasadena
Private Collection
Robert Harshorn Shimshak, Berkeley
Thomas Solomon's Garage, Los Angeles
Travis Somerville and Nancy Carol King,
 San Francisco
Roselyne and Richard Swig, San Francisco
Terrain, San Francisco
Shoshana Wayne Gallery, Santa Monica
Millie Wilson, Los Angeles

FOREWORD

The Fellows of Contemporary Art was established in 1975 as a nonprofit organization dedicated to the support of contemporary art in California. Since its inception, a strong emphasis has been placed upon supporting the work of emerging artists—a major interest of the members. To encourage young, talented artists and to make their work available to the public, we have organized several exhibitions showcasing new work under the title "Variations." This exhibition continues the tradition.

Members of the Fellows believe that not only is an exhibition important, but the accompanying catalogue provides significant art historical and educational documentation of the occasion and the work. Therefore, membership dues are used to underwrite exhibitions of contemporary California art and to publish scholarly documentation of these exhibitions.

We are extremely pleased to collaborate with the San Francisco Museum of Modern Art in sponsoring *Facing the Finish: Some Recent California Art*. In this regard, I would like to thank Jeanne Meyers, 1989 Fellows chairman of long range planning, for her efforts in initiating this show. We are immensely grateful to Fellow Susan Caldwell, who acted as liaison for the exhibition with its three venues, as well as to Catherine Partridge, current chairman of long range planning and exhibitions.

I would like to thank John Caldwell and Robert Riley, curators at the San Francisco Museum of Modern Art, for their insight in selecting the artists and their work for *Facing the Finish,* as well as John R. Lane, director of the Museum, and Barbara Levine, exhibitions coordinator. We are grateful to Betty Klausner, director of the Santa Barbara Contemporary Arts Forum, for her participation in and hosting of the exhibition's premiere. Thanks, too, to Steve Nowlin, director of exhibitions at the Art Center College of Design in Pasadena, for sponsoring the final stop of the exhibition tour at the Art Center's new gallery space in the spring of 1992.

I would especially like to thank the 175 members of the Fellows of Contemporary Art, whose contributions and enthusiasm have made this collaborative exhibition possible.

Virginia C. Krueger, Chairman
Fellows of Contemporary Art

FOREWORD

DIRECTOR'S

Given the lively contribution to the cultural life of California that has been made by the Fellows of Contemporary Art through the exhibitions this Los Angeles organization has sponsored over the past decade and a half, it was a special pleasure for the San Francisco Museum of Modern Art to have been invited to organize the 1991–92 edition in a distinguished, continuing series of projects. For this opportunity we particularly wish to express appreciation to Fellows board and staff members Virginia C. Krueger, chairman; Jeanne Meyers, former long range planning chairman; Susan Caldwell, exhibition liaison; and Alice E. Rotter, administrative director.

For their parts in the realization of the exhibition and the catalogue we are especially grateful to SFMOMA staff members John Caldwell, curator of painting and sculpture, and Robert R. Riley, curator of media arts, who collaborated as the organizers, assisted by Kara Kirk, Barbara Levine, Peter Samis, and Jane Weisbin.

In addition to the exhibition's San Francisco venue, it had its opening at Santa Barbara Contemporary Arts Forum and will close at the Art Center College of Design in Pasadena, where we thank, respectively, directors Betty Klausner and Steve Nowlin for their institutions' participation.

We are very grateful to the lenders to this exhibition, whose names are listed on a special page of this catalogue, and we appreciate the assistance of the artists' dealers and representatives, especially Luiz da Rosa and David Seibold of Art Lick Gallery, San Francisco; Rena Bransten of Rena Bransten Gallery, San Francisco; Pascale Rawley of Burnett Miller Gallery, Los Angeles; Mia von Sadovszky of Luhring Augustine Hetzler Gallery, Santa Monica; Mary Artino, Sam Durant, and Jeanne Meyers of Meyers/Bloom Gallery, Los Angeles; Tessa Wilcox and Michele Mincher of Mincher/Wilcox Gallery, San Francisco; Shoshana Wayne and Kevin Murphy of Shoshana Wayne Gallery, Santa Monica; Thomas Solomon of Thomas Solomon's Garage, Los Angeles; and Armando Rascon of Terrain, San Francisco.

The organizers of the exhibition also benefited greatly from advice and suggestions from members of the art community throughout California. The number of people consulted is too great to allow us to list them here individually, but their assistance was invaluable. To the

artists—Nayland Blake, Jerome Caja, Jim Campbell, David Kremers, Rachel Lachowicz, James Luna, Jorge Pardo, Sarah Seager, Christopher Williams, and Millie Wilson—we express our most sincere thanks for their close engagement in developing the presentations of their work in *Facing the Finish* and for the enrichment of the visual arts and the cultural life of the West Coast that ensues from their art.

The organization of the exhibition and the publication of its accompanying catalogue were made possible principally through the patronage of the Fellows of Contemporary Art, Los Angeles, and we are most grateful for the Fellows' support. The San Francisco presentation enjoys additional generous funding from Collectors Forum as an element of the San Francisco Museum of Modern Art's *New Work* series.

John R. Lane, Director
San Francisco Museum of Modern Art

INTRODUCTION

CURATORS'

Facing the Finish: Some Recent California Art is the product of a survey of work by young California artists, and as such it forms the fourth in a series of exhibitions sponsored by the Fellows of Contemporary Art entitled "Variations." Yet the exhibition is not itself a survey or a summary, an impossible goal in any case considering the quantity and diversity of good work being produced in the state today. It is instead the relatively compact result of a vast number of choices—too many made over a period of half a year even to be remembered now, much less categorized and written down. We started with the aim of producing an exhibition that would include the work of about ten of the best young artists we could find, but we soon found that this goal was impossible to achieve: there were simply too many artists producing too much good work. What finally took shape was something much more difficult to define, a constantly shifting but finally coalescing group of artists whose work seemed extraordinarily interesting and who somehow related to each other in a satisfying and meaningful way.

In the beginning we had no intention of producing what is sometimes called a theme show, a group of artists and works that could be taken to illustrate a particular point of view or set forth a definable style. Yet in looking at the exhibition as it has taken shape, and trying to find a title for it, a certain attitude has emerged. We have called the show Facing the Finish not because the artists or their work are apocalyptic or millenarian, but because they seem to have looked at the finish, whether of particular styles and movements in art, finding new meaning in the reconsideration of traditional forms, or the end of social or political structures, and then asked themselves what comes next. It is rather as if they looked at the finish, or, perhaps, finishes, from the other side, not in dread of what is to come but with the spirit of picking up the pieces and carrying on.

Overall, if one can take the somewhat risky step of characterizing the mood of the work in the exhibition, it might be termed guarded optimism, as if facing the exhaustion of certain pursuits in art and the end of certain aspects of society had left the artists feeling somehow refreshed, ready to start anew with the task of trying to understand themselves and the world around them. This is not to say, however, that this is somehow an art of resurgence or renascence.

There is work here, inevitably, whose subject is ecological disaster, implacable disease, or extreme personal difficulties, all of which are faced unflinchingly. Yet the response is generally somehow to get on with it, to take stock clearly and honestly, and to proceed to make something.

If the question were asked what in all this is particularly Californian, our answer would probably be not much. Although all of the work in the exhibition was made here by artists who have been residents of the state for an extended time, none of it could be said to be regional art. Many of the artists have shown their work on the East Coast and in Europe, and when encountered there it seems in no way odd or out of place. The work included here, then, is not so much California art as American art, and that, perhaps, is as it should be.

John Caldwell
Curator of Painting and Sculpture

Robert Riley
Curator of Media Arts

REMODELING

Robert Riley, Curator of Media Arts

*Notes on
Nayland Blake,
Jim Campbell,
James Luna,
Jorge Pardo, and
Millie Wilson*

JIM CAMPBELL

Lately, we have come to regard grim, sarcastic forms of visual art as a critique of our society and wry commentary on the art world itself. Here is a group of artists who, while knowledgeable of a punishing *"fin de siècle"* agenda, ponder a new set of concerns. These artists are caught in a web of mass-mediated information and seemingly endless image-reproduction capability, conditions that often make art seem an anachronism, the white-cube gallery structure a post-minimal cliché, and the notion of a framed image that attempts to direct attention to a singular sign or subject a fated device. Acutely conscious of their role as artists in such an environment, the artists featured in *Facing the Finish* do not trivialize or contest these concerns but rather face them optimistically. In the process, Jim Campbell, Nayland Blake, Millie Wilson, Jorge Pardo, and James Luna literally take things apart, decipher their content, and, in their reassembly, create works of particular significance.

Jim Campbell's video installation *Memory/Recollection* (1990) engages the fixed-frame, rectangular image in a live-camera, five-video-monitor matrix to provide a visual-art analogue to systems of inspiration, influence, and intervention, characteristic themes in many of the works on view in the exhibition. As is suggested by its title, images are stored as still frames on a video disc that is programmed by the artist to hold an array of "snap-shot" imagery. These images record moments from the sculpture's original state as well as from a number of its exhibition locations, both creating and referencing its own visual history. These historical images appear and decay generationally as they pass from one screen to the next in a left-to-right sequence, similar to a comic strip, but one that decomposes rather than develops.

An environment of live and degenerating images, the computer and video are Campbell's studio—an electronic and real-time medium in which perceptual dynamics and the stability of the frame enclosure, a contrivance on which we depend for certainty, are explored.

As Campbell creates in video a visual model of the beguiling influences evident throughout the exhibition, other artists resourcefully exploit a variety of visual art forms of the twentieth century including the decorative arts, Pop and Conceptual art practices, and the transactional materials of Post-Minimalism and Performance art. These artists perceive art history as a mate-

rial capable of being adapted to their contemporary desires. With a renewed interest in the art object itself, they create witty conundrums and use recognizable art as both form and symbol. Furthermore, diverse perspectives found in the artists' own cultural, racial, and visual identities are manifest in works that abound with colliding influences, tangential associations, and inspired commentary.

In Nayland Blake's *Still Life* (1990), a single, shelf-bound video monitor depicts a florid arrangement of props accompanied by an audio track. A black frame placed behind the color-saturated props jumps fitfully against the square TV frame, stressing an unexpected text exposed in their combination.

On the audio track, Blake's voice is heard reciting conversational excerpts from Stanley Kubrick's visionary 1969 science-fiction film *2001*. The dialogue between the astronaut, Dave, and the killer central nervous system space-mission computer, HAL, is attached to this other narrative framework to suggest a double meaning: "Just what do you think you are doing, Dave? My mind is going. I can feel it. I can feel it," intones Blake. "I can see you are upset and honestly think you should sit down calmly, take a stress pill and think things over," he continues ironically. In the film, Dave systematically dismantles the machine, taking HAL's life, while the computer attempts to resist verbally with automated expressions of fear. Here Blake reminds us there is *still life* to consider, even as HAL fails, shifting the narrative to challenge an unexamined perspective of hostile forces and loss; as an AIDS allegory of HIV infection, HAL attempts to act up, fight back with his admission that "I know everything hasn't been quite right with me lately. . . . I really think I'm entitled to an answer." And, in Blake's role as activist: "I still have the greatest enthusiasm for the mission . . . ," and finally the wrenching "I'm afraid . . . stop . . . will you . . . stop. . . ."

His selection of materials—hardware, decorative display paraphernalia, and popular cultural icons—is Blake's message-laden medium. The artist recognizes that emblems often have figurative, allegorical references and, in their manipulation, resonate emotional states. Blake's recent work combines media references that include artificial and decorative motifs such as flowers, dis-

tilling abstraction from the hyperrealism of mass-produced objects in order to create a form of media allegory.

The immediacy of video in Blake's *Still Life* is balanced in the exhibition by more reflective work such as the introverted, wall-bound piece *Hybrid #2* (1991), and the sculpture *Magic* (1991). *Magic,* a disquieting still life, presents a puppet, its open travel case, and a pile of dried flowers strewn in its honor. Blake frames another expression of loss with reverberating impact in this commemorative work that contains the marionette Madame, skinned from her armature and placed in state, not for one last, cherished look but for eternity. Wayland Flowers, the ventrilo-quist who once animated Madame in performance, died a few years ago of AIDS. Known for her remarks and sexual "schtick," Madame was an icon of 1970s gay-liberation sensibilities and here the poignancy of *Magic* is understood in the life lost behind the illusion. Now silenced and bound to her box, the marionette attests to new conditions of urgency.

The shock value of the outlandish confidence and conceptual underpinnings that inform each of Blake's constructions has considerable effect. The question of how allegory functions in a work of art forms an interesting network of associations in *Facing the Finish,* and is of concern to Blake as well as to the other artists featured. Looking past the surface—or the "finish"—of each of their works, identities and often harsh realities are objectified. An examination of these objects prompts us to ask some uneasy, compelling questions that haunt the times. Didacticism can begin to demystify content, but finally the attempt to explain undermines the very problems of meaning inherent in most of this work, and may furthermore be antithetical to the artists' insistence on permeable, elastic definition.

JORGE PARDO

As Blake makes choices from a variety of bewildering media, Jorge Pardo characteristically alters ordinary products such as advertising layouts, furniture, and household utilities to fit his ambitions as a visual artist. In Pardo's superficially austere work, a consideration of studio prac-tice and cultural environment may lend meaning. Pardo raises questions about the classifications of objects and the function of art. In his off-beat assemblages such as *David Alper and Susan Stein's Cabinet, 516 18th St., Santa Monica* (1990), based on a dresser and drawers, the artist con-verts utilitarian objects into composite forms, embedding a conscious revision and humorous intervention of criteria that define that object, and remakes the "original."

Artists shape the world, and our perspectives are shaped by their visions. But, in attempting to represent the world, the artist inevitably transforms it. Any reading of representation is often about much more than the factors that control definition such as pictorial elements, shape, and so on, but other criteria as well, such as questions about the artist's vision. Scrutinized by his imagination, such things are dismembered and demolished in Pardo's work. His materials externalize private sensibilities and questions are raised about objects, intention, and temperament that the artist doesn't answer, but rather leads the viewer into open territory of surprising conceptual premise and satisfying visual experience. Humor in works of art often underlines knowledge and critical thought. Pardo's forms, however spectacular and peculiarly compelling commodities, are useless. The value of art, he seems to say, is not in its function—such as design and architecture—but in the potential to reveal truths and consciousness.

James Luna, a Luiseño/Diegueño Indian who works out of the La Jolla Indian Reservation, uses original video in installation as a method of engaging autobiographical dialogue by inserting his own image and actions into a work of art.

Indian rituals fundamental to Luna's work are adapted to modern times through his distilled gesture, artifacts, tools, and television. Themes of absence and presence, loss and gain, anecdote and historical narrative are some of the dichotomies he explores in his installations. Identities are often presented in conflict with social realities, while historical precedent for Indian myth and behavior is referenced with artifact. Hardships and struggles are evident in Luna's symbolic equations that are made allegorical and immediate in video. *AA Meeting/Art History* (1990-91) not only refers to Western painting and sculpture, but also to the problems of ingesting toxins, poisoning, and substance abuse, making a vivid commentary on cultural assimilation.

A dark underside of social commentary is found throughout Luna's work, but a positive sense of the self—and a sense of humor—persist. Luna articulates and confronts problems associated with the American Indian such as alcoholism, blurred tribal identities, failure of public education, and loss of native languages, and strives to provide a framework of particular authority through which an aesthetic and social reality of his life and times is expressed.

As Luna creates environments from artifacts, verisimilitude, and video, Millie Wilson engages museum praxis as content in her work and, like Blake and Pardo, brings to bear an

JAMES LUNA

interpretation of objects counter to those prescribed by a utilitarian or conventional perspective. Courageous parodies of Minimalism, Surrealism, and Conceptual art, inherent in the tableau of Wilson's installation, expose the sexual subtext in work that has largely been theorized as cerebral. That sexual preference alters one's consideration of works of art is vehemently proclaimed in Wilson's ambitious series of installations. Created under the rubric *The Museum of Lesbian Dreams,* the artist intends to "invade high Modernism with a queer discourse."

Wilson's attention to the details of placement, texture, juxtaposition of objects, and photojournalism exposes unintentional puns which reveal, often comedically, the foundations of representation to be clichéd and exclusionary. Contrivance in the traditional display of art is examined, used to reference lesbian codes, and made to have anatomical references. For instance, where the frame was once intended to exclude the consideration of all else, in *The Museum of Lesbian Dreams* it is integrated as a metaphor and used to magnify leaps between the past and our fluctuating present. A contextual reading of exhibition wall colors, placement, and framed photographs of actual objects is affirmed as a sly statement of the experience of exhibition environments. Sexuality is not mute; it speaks to visitors in *The Museum of Lesbian Dreams.*

Works in *Facing the Finish,* such as *The Museum of Lesbian Dreams, Memory/Recollection, Magic,* and *AA Meeting/Art History,* all offer a framework for the interpretation of our world. Unique, charismatic art is both a challenge to the artist in its construction and to the viewer in its interpretation. Traditional, tried devices in visual art are no longer compatible with the tenor of the time, yet their manipulation is somehow relevant. Our investigation of the works in *Facing the Finish* should not likewise depend on contrived habit or perceptual laziness.

AFTER THE FINISH

John Caldwell, Curator of Painting and Sculpture

*Notes on
Jerome Caja,
David Kremers,
Rachel Lachowicz,
Sarah Seager, and
Christopher Williams*

CHRISTOPHER WILLIAMS

The title of *Angola to Vietnam* (1989) by Christopher Williams seems to promise a catalogue of accustomed horrors, photos, probably, of the human catastrophe of revolution and oppression in the Third World. What we get instead are pictures of flowers, twenty-seven black and white photographs of glass botanical models made in Dresden by Leopold and Rudolf Blaschka between 1887 and 1936 for the Botanical Museum of Harvard University. Williams has cross-referenced the countries of origin of the flowers in Harvard's collection with thirty-six nations where state terrorism is routinely practiced—countries listed by the Commission on International Humanitarian Issues and published in 1986 in the report *Disappeared!, Technique of Terror.* Seductively beautiful and elegant, the photographs, taken by Eric W. Luden under the artist's direction, come to seem like *fleurs du mal* when juxtaposed with the horrifying treatment of their citizens by the countries with which they are associated.

Ordinarily the twenty-seven photographs of *Angola to Vietnam* are exhibited with *Brasil* (1989), the literally appropriated front cover of the French fashion magazine *Elle.* Seen together, these works make clear that Williams's art is not at all about the arbitrary intersection of lists of Third World countries, but rather is a reflection of a reality so ubiquitous that almost any system of reference would produce similar results. On the fashion magazine we see the faces of five beautiful women representing "La Planète 'Elle,' le monde vu par les 'Elle' étrangers," and wearing sailor hats, labeled with the names of five Western countries, China, Japan, and Brazil, which is on a hat worn by a woman with slightly darker skin, the only country that also appears in *Angola to Vietnam.* One can hardly escape the conclusion that these countries actually exist in the Western mind simply as exotic locales, the place of origin of unusual flowers and beautiful women. Even the glass flowers themselves are occasionally broken and mended, and often held down by the wires that secure them in their cases, revealing both the artifice and fragility of their existence and creating a powerful metaphorical connection to the women in their absurdly labeled sailor hats. Williams thus reveals that a terrifying world has been reduced to a series of aestheticized, fragmentary images that bear only the most tenuous and fragile connection to reality.

Rachel Lachowicz

The relation of art to beauty is one of the central themes in the work of Rachel Lachowicz, as is perhaps nowhere more apparent than in a small sculpture entitled *Lipstick Cube* (1990). Only eight inches on each side, one sees it at first as a work of Minimal art related perhaps to the sculptures Joel Shapiro made a decade ago, only oddly colored in red. Despite the faint aroma of cosmetics permeating the gallery, it is only after reading the wall label that one quite believes what Lachowicz has done. It is then immediately evident that she has found a concrete metaphor, as it were, for exposing the artifice behind even so apparently pure an artistic practice as the simplicity and truth to materials of Minimalism. In another work, *Collagen* (1990), named for one of the miracle ingredients often advertised as present in cosmetics, the artist takes on a more recent target. Although it looks at first like one of Barnett Newman's zips applied rather oddly to a white wall, on closer inspection it is revealed to be a chair rail, à la Robert Gober, made of cast lipstick, again suggesting the "artiness"—or even stylishness—of important forms of artistic expression. In other works such as *Perpetuation and Stagnation* (1990), Lachowicz recreates in lipstick architectural details cast from nineteenth-century buildings. In this case, the viewer first reads the work in erotic terms, as the nipple and aureole of a breast, only to realize that the staid fabric of old buildings actually conceals the most glaring eroticism, clearly designed by male architects for male consumers. Although one can hardly help imagining the messy results of an encounter with these lipstick breasts, Lachowicz's purpose is not primarily satirical or comedic. Rather, she invites a serious reconsideration of the sources and meanings of the artistic impulse itself. Her work can be seen, in fact, in two ways, on the one hand suggesting that the most profound and everyday expressions of our civilization are but thinly disguised erotic impulses, almost always male, and on the other that the practice of decorating one's face with lipstick has deep connections with the essential elements of human nature.

Jerome Caja

Jerome Caja also uses cosmetics to make art, creating tiny, iconic paintings from nail polish and eyeliner, among other media. His connection with makeup is close, as he has another public persona, alongside his role as artist, as a thin, tattered drag queen. Caja's works painted on detritus such as bottle caps and restaurant change trays, mounted on bits of lace or crushed cans and the like, and sometimes devotional in content, can be likened to that of numerous practitioners of what today is usually called outsider art, though it is perhaps closer to the work of

Joseph Cornell. Unlike Cornell, who lived a hermetic life and whose art is often delicately fantastic, Caja is strongly connected to the real world. In one painting, two small yellow lovebirds are about to perish in a toaster, their fate ennobled by the golden light of McDonald's double arches. In another, an ordinary family made up of happily smiling eggs is having dinner. One of them frowns, however, because he has noticed that his brother has fallen from his jaunty egg-cup seat and become an irreparably broken egg on the floor. In fact, death runs through Caja's work as a leitmotif, sometimes combined with crude sexual humor, but perhaps most often in the form of a broken egg, lying beside its fragile shell, as if to provide an emblem for its daily occurrence as a result of AIDS. Indeed, it is possible to regard Caja's body of work as a whole, small in dimension and elaborately mounted and framed in the manner of medieval art, as a collection of magical talismans against death.

Caja is not a naif. He attended art school at the San Francisco Art Institute, and his work often attests to his study of the history of art—portrait heads, for example, that look very much like the bas-reliefs on Roman coins. It is possible to see him, in fact, as having retreated from the traditional public realm of painting, which today often seems to have lost conviction, into a private realm where absolute belief—and absolute need—may restore art's vital power to evoke the miraculous.

DAVID KREMERS

David Kremers, like Caja, has rejected traditional painting media to make works that reveal in their essence his doubts about the art of painting itself. At times he restricts himself to gesso on canvas, for instance, in an installation intended to be seen for only one day in a slightly bedraggled space where another exhibition has been taken down. In others, he achieves a simulacrum of the numinousness of reductive abstract painting by letting sunlight etch a geometric shape into inexpensive paper. When Kremers actually makes paintings, he expresses their titles in terms of the radioactive decay of chemical elements that are indicative of the chemical processes at work in the paintings themselves, which will continue to change and decay after they leave the artist's studio. Made of thirty-year-old, deteriorating house paint applied in small squares at the center of sheets of polished plywood, they resemble test patches of unknown materials in a scientific experiment and also recall the recent abstract paintings of Gerhard Richter. In any case, both their physical content and method of presentation suggest an art that is

highly provisional, an art that resists conviction as much as it thwarts interpretation and any pressure of belief. Like Caja, Kremers has taken painting to the margins of life, there to perform experiments on it and perhaps effect its resuscitation.

Sarah Seager

Sarah Seager also sees painting, at least in its traditional sense, as a marginalized activity. For Robert Ryman, white paint is a means of simplifying the problems of painting in order to analyze and explore them with more clarity. Seager's white paint is, by contrast, almost generic—something that serves, above all, to cover something else. She uses it to coat an element of a bed frame, to mark ax handles with repeating narrow bands, and to serve as the ground for plastic letters arranged in patterns that have no apparent meaning. Belonging to a generation that has understood and accepted the decline of the system of meanings and beliefs that supported abstract painting in recent years, Seager's utilitarian approach to the medium is not so much reductive as simply matter-of-fact. One is inclined to see her work as reconstructive because starting over with the prosaic and actual has continually served in modern art as the basis for something new. Thus, a piece of bed frame, coated many times in white paint, can be at the same time utterly ordinary and expressive of an oddly literal thrust toward the extraordinary. It is probably accidental that her neon piece *SING* (1989) repeats the evocation of the muse used to begin epic poems ever since Homer, yet when one actually encounters it, a basic human impulse responds. Like Homer's muse we feel called upon to sing.

It is quite evidently not possible to assimilate the artists in this exhibition into a single stylistic or conceptual entity. Their work and their concerns are entirely too various and even divergent for that to be a reasonable goal. Perhaps one can, however, characterize the work included here in terms of an attitude and a moment in time. If one takes the word *finish* in the exhibition's title to refer to the elegiac and even apocalyptic world view that prevailed a few years ago, these artists would appear to be looking at that apparent terminus from the other side. One has now, and particularly in California, a sense not so much of endings as of new beginnings, of clear-eyed recognition of political and environmental crisis combined with a determination to go on with things. These artists make one wonder if the depressed mood of the art of only a few years ago was the result not of intractable problems and the inability to see a viable future but rather of the decline of a certain world view that for many years has been at the root of American

culture. One senses in California, of all places, that our Edenic assumptions have finally been laid to rest, and that in artistic terms the American sublime has disappeared as a goal and probably even as a possibility. It is conceivable that what in terms of this exhibition might be called the culture of K-Mart is in fact a more solid ground to build on than the inherently religious world view of the recent and relatively distant past. What we may be seeing here is that to limit apparent ambitions, to surrender, as it were, the sublime, makes it possible to grasp reality and work with it—in short, to make art.

NAYLAND BLAKE

Hybrid #2, 1991 (Checklist no. 3)

Magic, 1990–91 (Checklist no. 4)

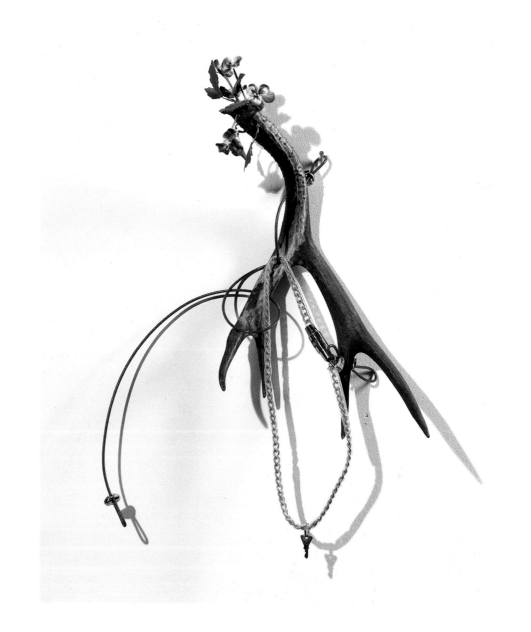

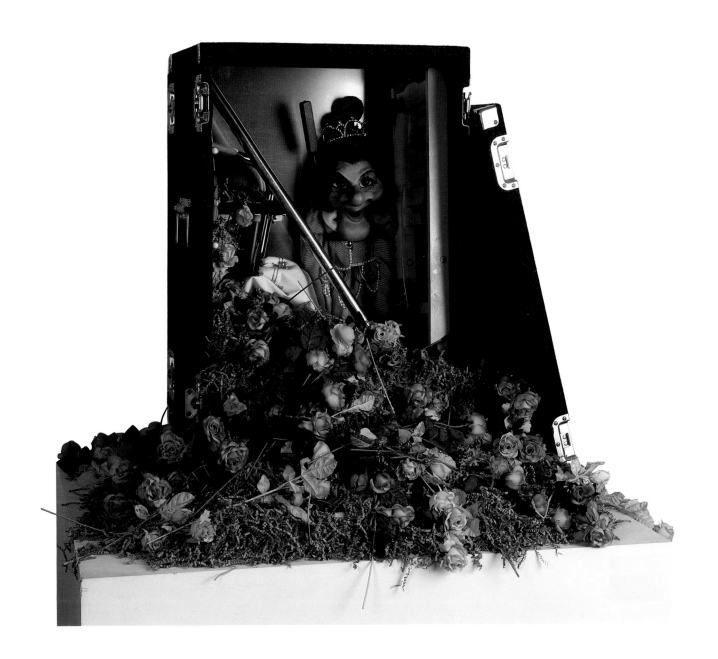

JEROME CAJA

Eggs Having Turkey Dinner, 1989
(Checklist no. 10)

Lovebirds at McDonald's, 1991
(Checklist no. 30)

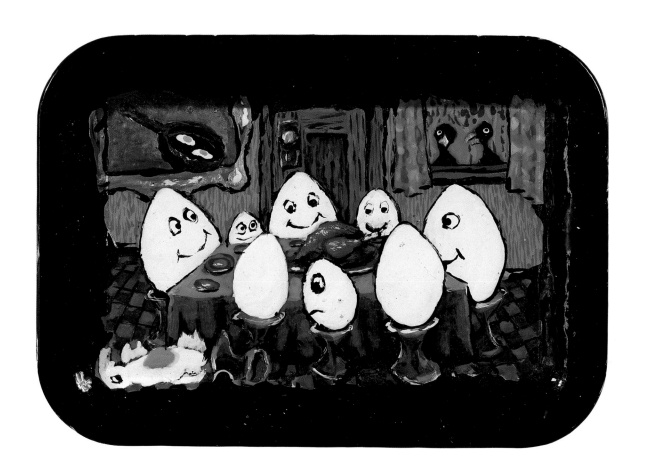

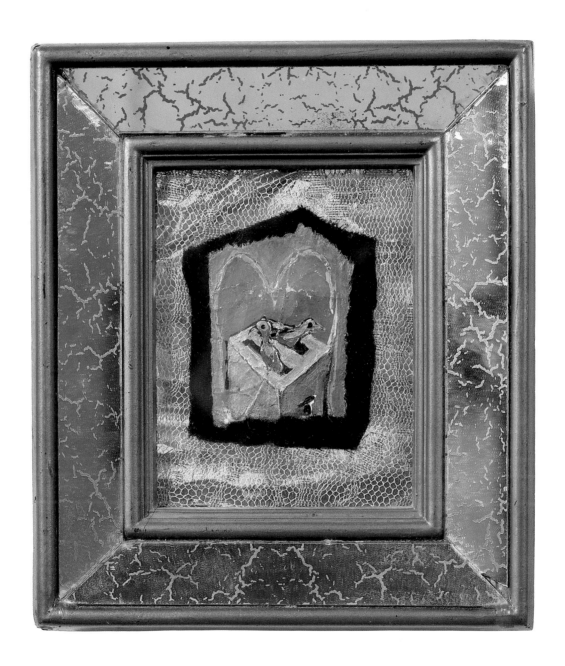

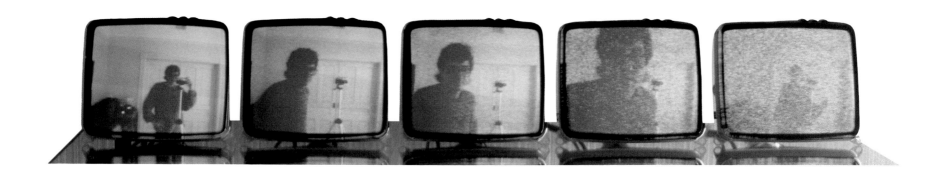

Jim Campbell

Memory/Recollection, 1990
(Checklist no. 43)

Light, 1991 (Checklist no. 45)

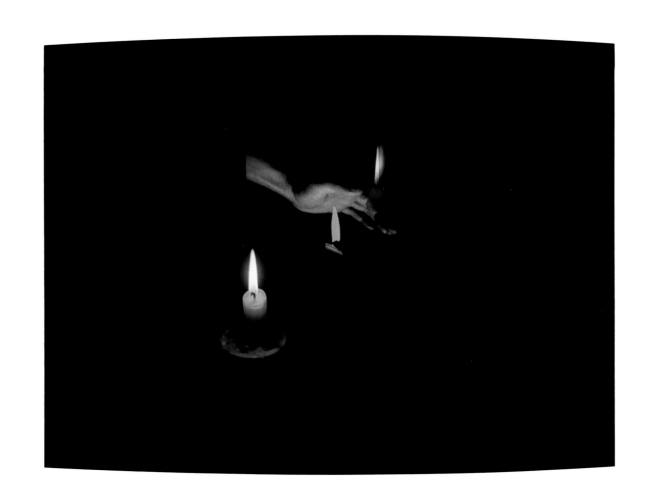

DAVID KREMERS

Untitled, from the *Sun on Paper* series,
1989 (Checklist no. 48)

$^{228}_{88}Ra$ *(5.76 years),* from the *Chemical
Isotope* series, 1990
(Checklist no. 47)

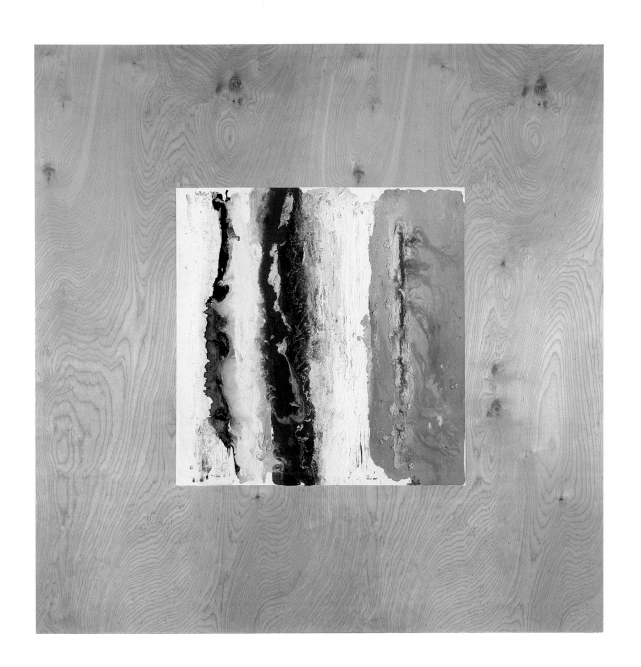

Rachel Lachowicz

Lipstick Cube, 1990 (Checklist no. 53)

Third String, 1990 (Checklist no. 54)

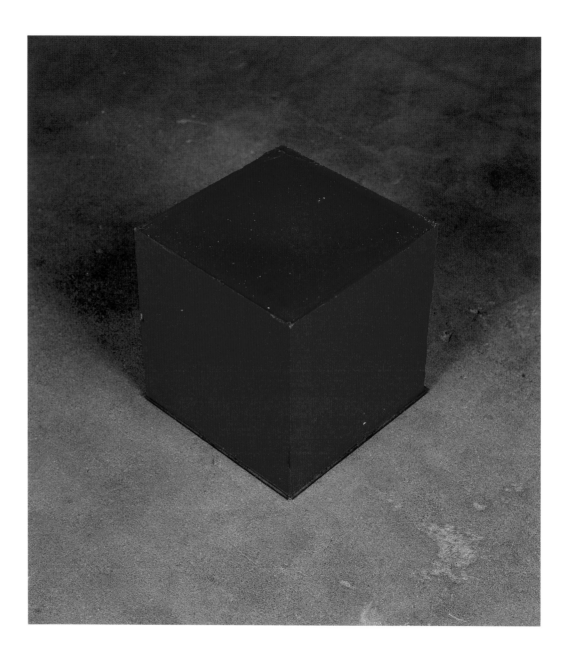

JAMES LUNA

AA Meeting/Art History, 1990–91
(Checklist no. 56)

Wake/Velorio (He's Resting Now), 1985
(detail), (Checklist no. 57)

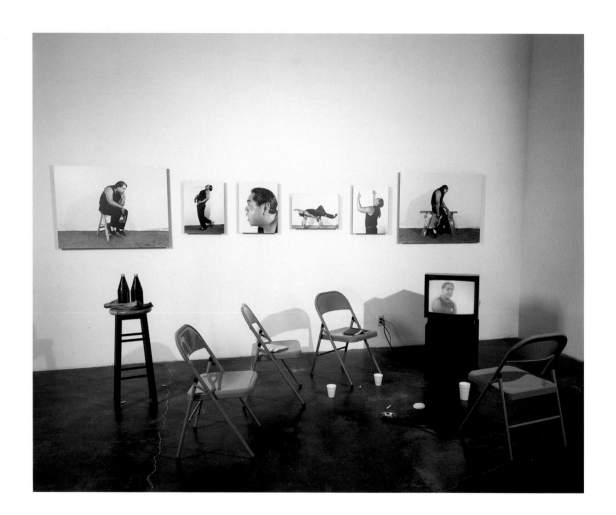

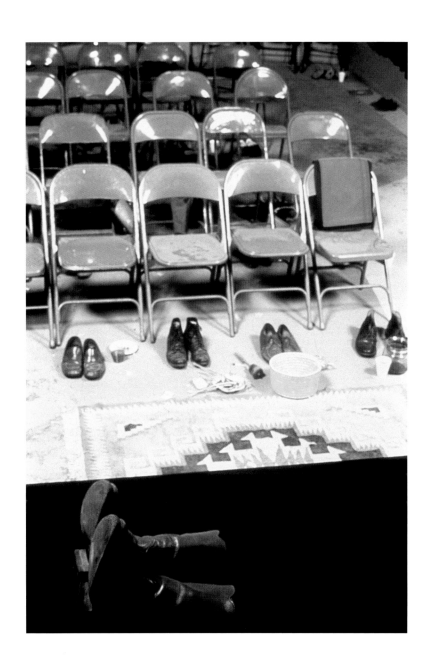

Jorge Pardo

David Alper and Susan Stein's Cabinet,
516 18th St., Santa Monica, 1990
(Checklist no. 58)

Herbert Matter Painting (Diptych), Arts and
Architecture September 1946, page 40 & 41,
1991 (Checklist no. 59)

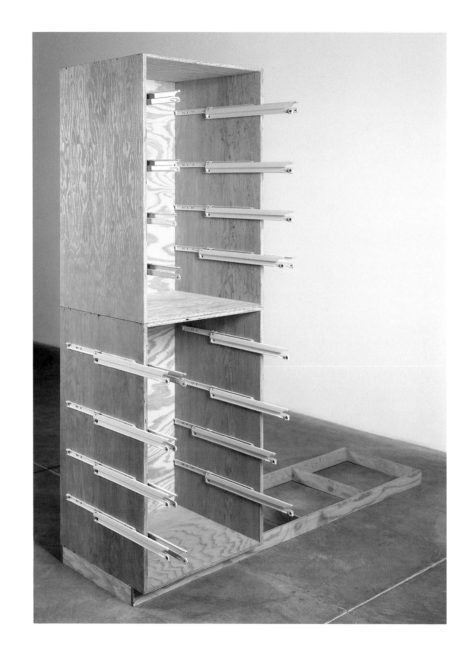

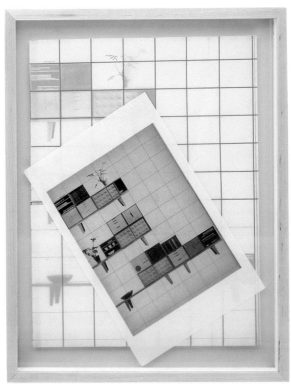

Sarah Seager

SING, 1989 (Checklist no. 63)

White Rail, 1990 (Checklist no. 64)

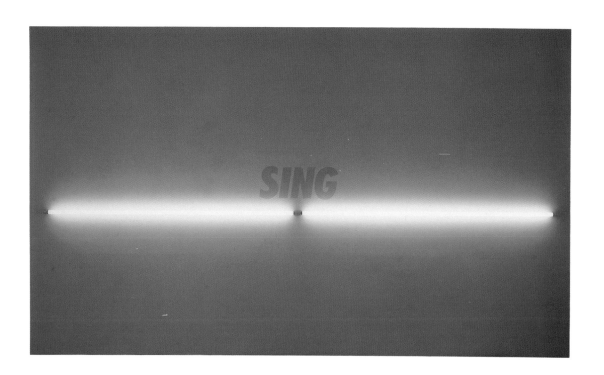

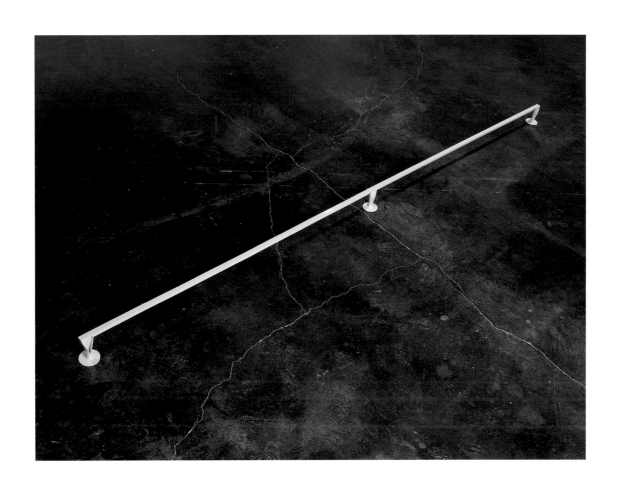

CHRISTOPHER WILLIAMS

Brasil, 1989 (Checklist no. 68)

Philippines, from the *Angola to Vietnam* series, 1989 (Checklist no. 69)

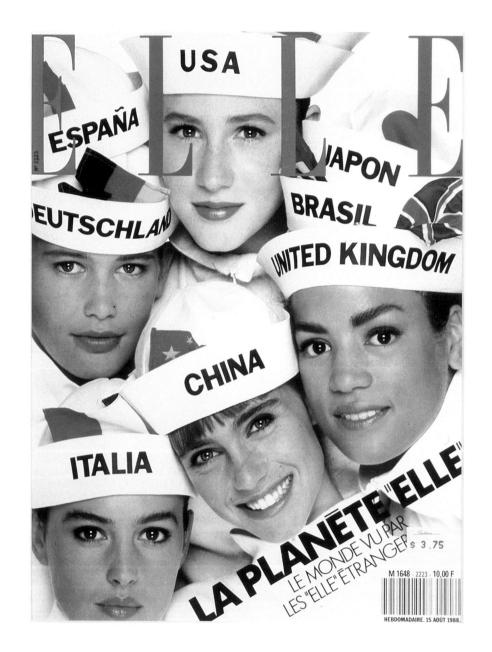

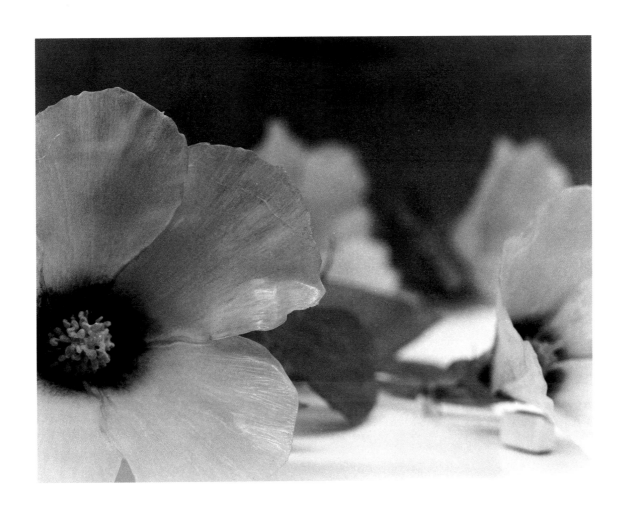

MILLIE WILSON

Language of Dreams, from *The Museum of Lesbian Dreams,* 1991 (Checklist no. 76)

Twisted Love, 1991

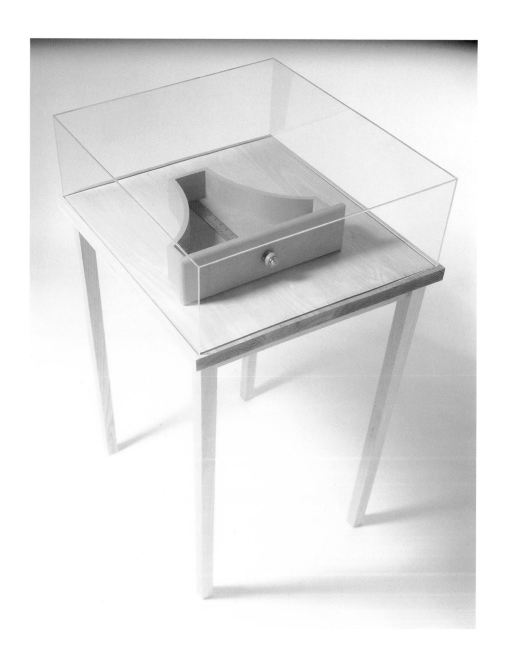

Bold and Innocent	Club Unique	Constant Urge	Double-Crossed Beds
Female Convict	Girl After Girl	Golden Nymph	Joy Wives
Lady Stud	Lust Has No Mercy	Maybe Sex	Odd Kind
Oversexed	Perversion Resort	Second Fiddle	Secret Places
Sex Haven	Silken Underground	Strands of Lust	Strange Breed
Take Me in Passion	That Kind of Girl	Too Ready for Love	They Were Too Much
Trouble in Skirts	Twilight Sin	Twisted Path	Two of a Kind

AND BIBLIOGRAPHIES

BIOGRAPHICAL DATA

NAYLAND BLAKE

Born in New York, 1960
Lives and works in San Francisco

Education

Bard College, Annandale-on-Hudson, New York,
B.F.A., 1982
California Institute of the Arts, Valencia, M.F.A.,
1984

Individual Exhibitions

1985 *The New Testament, Book One: Der
 Spinnen,* New Langton Arts,
 San Francisco
1986 *B, B, & B,* 3735 Gallery, San Francisco
1987 *Inscription,* XS Gallery, Carson City,
 Nevada
 Boredom of the Hyperboreans, San Francisco
 Camerawork Bookstore
1988 *From Paths of Pain to Jewels of Glory,* Media,
 San Francisco
 Windows Since 1903, San Francisco
1989 Richard Kuhlenschmidt Gallery,
 Santa Monica
 The Elision of Failed Effect, Mincher/
 Wilcox Gallery, San Francisco
 The Schreber Suite, Matrix Gallery,
 University Art Museum, Berkeley
1990 *Punch Agonistes,* Richard Kuhlenschmidt
 Gallery, Santa Monica
 The Sacher-Masoch Suite, Simon Watson,
 New York
 Low, Petersburg Gallery, New York

Group Exhibitions

1986 33 Grant, San Francisco
 Artists and Models, LACE (Los Angeles
 Contemporary Exhibitions)
1987 *Reconnaissance,* Media, San Francisco
 Art Installs, ProArts, Oakland
 Chain Reaction 3, San Francisco Arts
 Commission Gallery
 Gypsies, Tramps and Thieves, Works,
 San Jose
1988 *The Other Sex,* Hallwalls Contemporary
 Arts Center, Buffalo
 American Fine Arts, New York
 303 Gallery, New York
 Beyond the Camera Obscura, San Francisco
 Arts Commission Gallery
 Fuller Gross Gallery, San Francisco
 Assemblage '88: The Recontexualized Object,
 San Francisco Art Institute
 In Evidence, Randolph Street Gallery,
 Chicago
1989 Richard Kuhlenschmidt Gallery, Santa
 Monica
 Bard College, Annandale-on-Hudson,
 New York
 Against Nature, LACE, Los Angeles
 Invitational, Stux Gallery, New York
 Retro Future, Richard/Bennett Gallery,
 Los Angeles
 Restraint/Intent/Manipulation, Mincher/
 Wilcox Gallery, San Francisco
 Erotophobia, Simon Watson, New York

1989 *The New Narratology,* Artspace Annex,
San Francisco; Santa Cruz County Art
Museum; Miami Center for the Fine Arts;
Center for Contemporary Art, University
of Texas, Arlington
Image World, Whitney Museum of
American Art, New York
Remainders, White Columns, New York
The Second Second, Althea Viafora Gallery,
New York

1990 *The Clinic,* Simon Watson, New York
New Work: A New Generation,
San Francisco Museum of Modern Art
The Köln Show, Esther Shipper and Sophia
Unger, Cologne
Mind Over Matter, Whitney Museum of
American Art, New York
Stendhal Syndrome: The Cure, Andrea
Rosen Gallery, New York
*SECA Art Award 1990: Nayland Blake,
John Meyer,* San Francisco Museum of
Modern Art

1991 *Anni Novanta (The Nineties),* Galleria
Communale d'Arte Moderna,
Bologna, Italy
Mincher/Wilcox Gallery, San Francisco
Something Pithier and More Psychological,
Simon Watson, New York
1991 Biennial Exhibition, Whitney
Museum of American Art, New York
Someone or Somebody, Meyers/Bloom
Gallery, Los Angeles

1991 *The Interrupted Life: On Death and Dying,*
The New Museum of Contemporary Art,
New York
Artists' Books, Lorence-Monk Gallery,
New York
The Library of Babel: Books to Infinity,
Hallwalls Contemporary Arts Center,
Buffalo
Telekinesis, Mincher/Wilcox Gallery,
San Francisco
Currents, Institute of Contemporary Art,
Boston

Bibliography

Abbott, Todd. "Tart Art from a Bad Boy."
The Advocate, August 28, 1990, 66–67.

Acker, Kathy and Nayland Blake. *Low* (exh. cat.).
New York: Petersburg Gallery, 1990.

Baker, Kenneth. "Objects at Media Gallery."
San Francisco Chronicle, February 24, 1987.

———. "Nayland Blake at Mincher/Wilcox."
San Francisco Chronicle, November 7, 1989.

Baron, Todd. "Narratives of Repression." *Artweek*
21, no. 20 (May 24, 1990): 13.

Berkson, Bill. "Reviews: San Francisco, Nayland
Blake, Media." *Artforum* 25, no. 9 (May 1987): 157.

Blake, Nayland. [3 wks. illustrated] *BOMB* no. 34
(Winter 1991): 72–3.

Bleckner, Ross. "Infostructure." *Interview* 21,
no. 4 (April 1991): 26.

Bonetti, David. "Portrait of the artist as a dandy."
San Francisco Examiner, October 29, 1989.

———. "In search of a gay sensibility." *San Francisco
Examiner,* June 25, 1991, sec. C, 1.

———. "SF art world knows no season." *San
Francisco Examiner,* June 25, 1991, sec. C, 1.

———. "Report from the Bay Area." *Art New
England* 11, no. 8 (September 1990): 33.

———. "Bay Area Art: The Lost Bohemia."
Artnews 89, no. 10 (December 1990): 118–23.

———. "Highlights of the museum season."
San Francisco Examiner, September 9, 1990.

———. "Contemporary trends in opposition."
San Francisco Examiner, September 28, 1990.

Brenson, Michael. "Nayland Blake." *New York
Times,* October 19, 1990.

———. "In the Arena of the Mind, at the Whitney."
New York Times, October 19, 1990.

Caldwell, John. *New Work: A New Generation*
(exh. cat.). San Francisco: San Francisco Museum
of Modern Art, 1990.

———. *SECA Art Award 1990: Nayland Blake, John
Meyer* (exh. cat.). San Francisco: San Francisco
Museum of Modern Art, 1990.

Cameron, Dan. "The Sexual is Cultural." *Art & Auction* 13, no. 5 (December 1990): 88, 90.

"Co-Conspirators: Nayland Blake and Kathy Acker." *Cover* 4, no. 8 (October 1990): 10.

D'Amato, Brian. "Mind Over Matter." *Flash Art* 24, no. 156 (January/February 1991): 134.

Faust, Gretchen. "New York in Review." *Arts* 64, no. 7 (March 1990): 118–19.

Fehlau, Fred. "Against Nature: Whose Nature?" *Art Issues* no. 4 (May 1989): 19.

———. "Nayland Blake, Richard Kuhlenschmidt, Santa Monica." *Flash Art* 23, no. 154 (October 1990): 190.

French, Christopher. "A Taste for Narration at the Whitney: Conceptual Sculpture for the '90s." *The Journal of Art* 3, no. 2 (November 1990): 15.

Friedman, Robert. "Whips, Restraints, and Cattle Prods…" *San Francisco Sentinel,* October 25, 1990, 22.

Gerstler, Amy. "Reviews, Los Angeles: Against Nature, LACE." *Artscribe International,* no. 75 (May 1989): 86–87.

Hammer, Jonathan. "Under the First Amendment: Nayland Blake Reviewed by Jonathan Hammer." *Shift* 1, no. 1 (1987): 27.

Helfand, Glen. "Old Objects, New Ideas." *San Francisco Sentinel,* February 20, 1987.

———. "Notable Offerings." *San Francisco Sentinel,* January 8, 1988.

———. "Objects of Desire." *Artweek* 19, no. 36 (October 29, 1988): 4.

———. "Seeking Art World Success in S.F." *SF Weekly,* September 19, 1990.

Hirsh, David. "Dangerous Images." *Bay Area Reporter,* September 27, 1990.

Hixson, Kathryn. "Chicago in Review." *Arts* 63, no. 7 (March 1989): 106.

Jan, Alfred. "Audience Response to 'New Work: A New Generation.'" *Visions Art Quarterly* 4, no. 3 (Summer 1990): 24–26.

Kandel, Susan. "L.A. in Review." *Arts* 64, no. 2 (October 1989): 108.

———. "L.A. in Review." *Arts* 65, no. 1 (September 1990): 108–9.

Levin, Kim. "Choices: Art." *Village Voice,* October 24, 1990: 105.

Mahoney, Robert. "New York in Review." *Arts* 65, no. 5 (January 1991): 102–3.

Morgan, Stuart. "Low: Good and Evil in the Work of Nayland Blake." *Artscribe International* no. 85 (January/February 1991): 99.

Morris, Gay. "San Francisco: Nayland Blake at Mincher/Wilcox." *Art in America* 78, no. 3 (March 1990): 209–10.

Pacheco, Patrick. "Art Gets Serious With a New Set of Stars." *New York Times,* March 3, 1991, sec. 2, 1, 25.

Pagel, David. "Nayland Blake: Props and Phantoms." *Art Issues,* no. 13 (September/October 1990): cover, 12, 13.

Porges, Maria F. "Sculptural Wordplay." *Artweek* 18, no. 12 (March 28, 1987): 3.

———. *The New Narratology: Examining the Narrative in Image-Text Art.* San Francisco: Words & Pictures, 1989.

———. "John Caldwell: Pioneering the New." *Contemporanea,* no. 22 (November 1990): 83.

———. "You're History, Pal: Reading Nayland Blake." *Artforum* 29, no. 3 (November 1990): 119–23.

Rubinstein, Meyer Raphael. "Nayland Blake: If It's Too Loud, You're Too Old." *Flash Art* 24, no. 156 (January/February 1991): 123.

Snider, Burr. "Warm response to art for AIDS." *San Francisco Examiner,* May 19, 1989.

Strauss, David Levi. "Examining the Narrative in Image-Text Art, Artspace Annex." *Artscribe International,* no. 78 (November/December 1989): 84.

Thrush, Glenn. "Wherefore Art Now." *Downtown Express,* January 16, 1991, 3–5.

Van Proyen, Mark. "Revenge of the Seventies." *Artweek* 21, no. 36 (November 1, 1990): 1, 20.

Weissman, Benjamin. "Reviews: Los Angeles, Nayland Blake, Richard Kuhlenschmidt Gallery." *Artforum* 28, no. 1 (September 1989): 154.

JEROME CAJA

Born in Cleveland, 1958
Lives and works in San Francisco

Education

Cleveland State University, B.A., 1984
San Francisco Art Institute, M.F.A., 1986

Exhibitions and Performances

1984 *Babydoll,* Cleveland Museum of Art
Little Accidents, Cleveland Museum of Art
1986 *Hospital Party,* San Francisco Art Institute
Art Now '86, San Francisco Art Institute/
Fort Mason Center
1989 *X,* Art Lick Gallery, San Francisco
Gogo to Hell, Art Lick Gallery,
San Francisco
Housewife, A Different Light,
San Francisco
Cats, Force Nordstrom Gallery,
San Francisco
Cosmetic Miracles, Force Nordstrom
Gallery, San Francisco (individual
exhibition)
1990 *Sophia,* Art Lick Gallery, San Francisco
High Heel Wrestling, Das Klub,
San Francisco
1991 Bienville Gallery, New Orleans

Bibliography

Abbott, Steve. "As the Legend Grows: A Chat
with Jerome About His Life and Art." *Bay Area
Reporter* 20, no. 14 (April 5, 1990): 29, 36.

——. "The Vision of a Saint." *Bay Area Reporter*
20, no. 14 (April 5, 1990): 37.

*Art Now '86, San Francisco Art Institute M.F.A.
Graduate Exhibition* (exh. cat.). San Francisco:
San Francisco Art Institute, 1986.

Bonetti, David. "Drag queen waxes cosmetic to
create 'Compact' exhibit." *San Francisco Examiner,*
April 11, 1990, sec. B, 3.

——. "Explosion of gay, AIDS art." *San Francisco
Examiner,* June 22, 1990, sec. C, 2.

——. "Dear Diary: What a party! From weird to
outrageous during gay freedom week."
San Francisco Examiner, June 28, 1990.

Helfand, Glen. "Visible Alternatives." *S.F. Weekly,*
August 30, 1989, 9.

"The 65th May Show." *Ceramic Monthly* 32, no. 9
(November 1984): 25.

Strauss, David Levi. "Jerome Caja, Force
Nordstrom Gallery." *Artforum* 27, no. 8 (April
1989): 171–72.

JIM CAMPBELL

Born in Chicago, 1956
Lives and works in San Francisco

Education

Massachusetts Institute of Technology, S.B., 1978

Selected Exhibitions

1978 Massachusetts Institute of Technology,
Film/Video Section
1988 *A Season in Hell,* Temporary exh. space at
Turk & Eddy streets (Tenderloin),
San Francisco
1990 *Bay Area Media,* San Francisco Museum of
Modern Art
Fifteenth Anniversary Show, New Langton
Arts, San Francisco
Inner Tensions, ProArts Open Studio,
Emeryville, California
1991 *Hallucination,* Fresno Art Museum
Le Printemps de PRIM, PRIM
(Productions Réalisations Indépendantes
de Montréal), Montréal

Selected Screenings

1980 San Francisco Video Festival
1981 International Electronic Music Festival,
Brussels
Big Video Show, DeCordova Museum,
Lincoln, Massachusetts
1983 International Avant-Garde Festival, Paris
Big Video Show, DeCordova Museum,
Lincoln, Massachusetts
1984 International Festival of New Cinema,
Montreal
Coastal Extremes, San Francisco and
Boston

1985 Turin Film Festival, Italy
 American Independent Feature Film
 Market, New York
1986 Athens Film Festival, Ohio
 Red Victorian Theater, San Francisco
1988 Grey Art Gallery and Study Center,
 New York University, New York

Bibliography

Anbian, Robert. "Reflections on 'Bay Area
Media.'" *Release Print* 13, no. 4 (May 1990): 6.

Baker, Kenneth. "Artists Channel Bay Area
Environment." *San Francisco Chronicle,* March 25,
1990, *This World/Review:* 13–14.

———. "A Striking Video Chops Up Streisand."
San Francisco Chronicle, August 9, 1990.

Benet, Carol. "The Arts: The Bay Area Media
Show Takes Video to the Edge." *The Ark*
(Tiburon, California), April 11, 1990.

Carrière, Daniel. "Quand les machines rêvent."
Le Devoir (Montreal), May 18, 1991.

Fish, Tim. "Art of The City." *Santa Rosa Press
Democrat,* April 13, 1990, sec. D, 1.

Jan, Alfred. "Video Installations at New Langton
Arts." *Visions Art Quarterly* 5, no. 1 (Winter 1990):
48.

Lepage, Jocelyne. "Le Printemps de PRIM:
les arcades culturelles de l'avenir." *La Presse*
(Montreal), May 25, 1991.

Morgan, Anne Barclay. "Interactivity in the
Electronic Age." *Sculpture* 10, no. 3 (May/
June 1991): 41.

O'Connor, Rory J. "From Dada to data:
Programming in, fine art out—brave new world
of the 'interactive.'" *San Jose Mercury News,*
March 23, 1990, sec. D, 1, 14.

Reveaux, Tony. "Polytechnical Diversity." *Artweek*
21, no. 15 (April 19, 1990): 1, 20.

Silva, Elio. "Allucinazioni e contatti profondi."
Il Sole-24 Ore (Milan), April 22, 1990, 27.

Soe, Valerie. "SFMOMA exhibit probes man's
relationship to technology." *Film/Tape World* 3,
no. 3 (April 1990): 10.

DAVID KREMERS

Born in Denver, 1960
Lives and works in Malibu and Denver

Education

Pepperdine University, Malibu, B.A., 1985

Individual Exhibitions

1990 *Equation Paintings,* Thomas Solomon's
 Garage, Los Angeles
 Ghost Paintings, Thomas Solomon's
 Garage, Los Angeles
1991 *Reality Paintings,* Galerie Xavier Hufkens,
 Brussels

Group Exhibitions

1990 *L.A., My Third Lady,* Galerie Tanja
 Grunert, Cologne
1991 *Five Days,* Thomas Solomon's Garage,
 Los Angeles

Rachel Lachowicz

Born in San Francisco, 1964
Lives and works in Los Angeles

Education

California Institute of the Arts, B.F.A., 1988
Skowhegan School of Painting and Sculpture,
Skowhegan, Maine, 1988 (painting fellowship)

Individual Exhibitions

1989 Krygier/Landau Contemporary Art,
 Santa Monica
 Dennis Anderson Gallery, Antwerp,
 Belgium
1990 Krygier/Landau Contemporary Art,
 Santa Monica
1991 Shoshana Wayne Gallery, Santa Monica
 Dennis Anderson Gallery, Antwerp,
 Belgium

Selected Group Exhibitions

1989 *Modern Objects,* Richard/Bennett Gallery,
 Los Angeles
 Sculpture from New York and Los Angeles,
 Krygier/Landau Contemporary Art,
 Santa Monica
1990 *Aperto,* Galleria Notturna d'Arte
 Contemporanea, Milan
 Membership Has Its Privileges (collaboration
 with Gary Simmons), Lang & O'Hara
 Gallery, New York
 Contemporary Arts Forum,
 Santa Barbara

1991 Dennis Anderson Gallery, Antwerp,
 Belgium
 Five Days, Thomas Solomon's Garage,
 Los Angeles

Bibliography

Clearwater, Bonnie. "Lettre de Los Angeles." *Art Press,* no. 146 (April 1990): 86.

Crowder, Joan. "Catching the Spirit of Our Time." *Artweek* 21, no. 43 (December 20, 1990): 20.

Doove, Edith. "Feminisme in Lippenstift" (Feminism in lipstick). *Het Nieuwsblad* (Antwerp, Belgium), May 29, 1991.

Frank, Peter. "To Be Young, Gifted and Los Angeleno." *Visions Art Quarterly* 3, no. 3 (Summer 1989): 24–28.

———. "Art Pick of the Week." *LA Weekly* 11, no. 43 (September 29–October 5, 1989).

Greer, Suvan. "The Galleries: Santa Monica." *Los Angeles Times,* September 15, 1989, sec. VI, 21.

Hammond, Pamela. "Sculpture Krygier/Landau." *Artnews* 88, no. 5 (May 1989): 178.

Ruiters, Mark. "Antwerpen Galeries: Lachowicz – Burkhart." *Kunst und Kultur* (Brussels), June 1991.

Snow, Shauna. "Rachel Lachowicz's New Role: 'Just Looking at Life.'" *Los Angeles Times,* December 16, 1990, 109.

Zellen, Jody. "Rachel Lachowicz." *Arts* 65, no. 7 (March 1991): 85.

James Luna

Born in Orange, California, 1960
Lives and works on the La Jolla Indian Reservation

Education

University of California, Irvine, B.F.A., 1976
San Diego State University, M.S. in Counseling, 1983

Individual Exhibitions

1974 Bank of America, Irvine
1975 Carl Gorman Gallery, University of
 California, Davis
1981 Rolando Castellon Gallery, San Francisco
 Carl Gorman Gallery, University of
 California, Davis
1982 San Jose State University
1985 Centro Cultural de la Raza, San Diego
1989 *Two Worlds,* INTAR Gallery, New York
1990 *2 Worlds,* American Indian Community
 House Gallery, New York
1991 *Selected Works 1990–91,* Boehm Gallery,
 Palomar College, San Marcos, California

Group Exhibitions

1975 *Native American Art Exhibit,* State Capitol
 Building, Sacramento
 Native American Art, University Art
 Gallery, San Diego State University
1986 Hippodrome Gallery, Long Beach
 Made in Atzlan, Centro Cultural de la
 Raza, San Diego
1987 *Art and Culture Show,* Public Art Advisory
 Council, San Diego
 En Memoria Show, Centro Cultural de la
 Raza, San Diego
 Street Sets Show, Sushi Gallery, San Diego

1988 *Up Tiempo!,* Museo Del Barrio/Creative
 Time, New York
 California Mission Daze, Installation
 Gallery, San Diego
 Native American Art in the '80s, Riverside
1990 *Oh, Those Four White Walls,* Atlanta
 College of Art, Atlanta
 Disputed Identities, SF Camerawork,
 San Francisco
 California Indian Conference Art Show,
 Riverside
 The Tell Tale Heart, Washington Project
 for the Arts, Washington, D.C.
 The Decade Show, The New Museum of
 Contemporary Art, New York
1991 *SITEseeing,* Whitney Museum of
 American Art, New York
 Shared Visions, The Heard Museum,
 Phoenix
 Contemporary American Indian Art, San
 Bernadino County Museum, Redlands,
 California
 Submuloc Show or Columbus Wohs,
 Evergreen College, Olympia, Washington

Selected Bibliography

Avalos, David, James Luna, Deborah Small, and
William E. Weeks. *California Mission Daze* (artists'
book), 1988.

*The Decade Show: Frameworks of Identity in the
1980s* (exh. cat.). New York: Museum of
Contemporary Hispanic Art, The New Museum
of Contemporary Art, and The Studio Museum
in Harlem, 1990.

Green, Frank. "Debate swirls over Serra sanctity."
San Diego Union, September 21, 1988, sec. C, 1.

Henshaw, Jean. "Turmoil inspires an Indian's art."
San Diego Tribune, June 7, 1990, sec. B, 13–14.

Hess, Elizabeth. "The Decade Show: Breaking
and Entering." *Village Voice* 35, no. 23 (June 5,
1990): 87–88.

James Luna (exh. cat.) San Francisco: Rolando
Castellon Gallery, 1981.

James Luna (exh. cat.) San Diego: Centro Cultural
de la Raza Gallery, 1985.

Jarmusch, Ann. "Artists dance with two cultures."
San Diego Tribune, March 29, 1991.

Joselit, David. "Living on the Border." *Art in
America* 77, no. 12 (December 1989): 127–28.

Learn, Scott. "Indian artist turns mirror towards
life on reservation." *Times Advocate* (Escondido,
California), April 18, 1990.

Lugo, Mark-Elliott. "Centro exhibits by Luna,
Mercado not for the timid." *The Tribune*
(San Diego), August 23, 1985.

Luna, James. "The Artifact Piece." In *Fiction
International,* edited by Harold Jaffe and Larry
McCaffery, 38–42. San Diego: San Diego State
University Press, 1988.

———. Untitled artist's brochure for *The Tell Tale
Heart,* with an interview by Mel Watkin.
Washington, D.C.: Washington Project for the
Arts, 1990.

McKinnie-McCoy, Ruth. "Indian art draws on
past: Alcoholism, wake subjects of work." *The
Tribune* (San Diego), August 22, 1985.

McWillie, Judith. "James Luna: Two Worlds/Two
Rooms." In *James Luna: Two Worlds* (exh. cat.).
New York: INTAR Gallery, 1989.

Ollman, Leah. "At the Galleries: Wry, Poignant
Look at Life as an Indian." *Los Angeles Times*
(San Diego ed.), March 20, 1991.

———. "Exhibit Paints Serra in Un-Saintly Glow:
'California Mission Daze' joins Fray Over
Treatment of Indians." *Los Angeles Times*
(San Diego ed.), October 12, 1988, sec. VI, 1.

Pincus, Robert L. "Luna captures contradictions
in life of Native Americans." *The San Diego Union,*
March 22, 1991.

———. "Sushi puts art on the streets with works on
public sites." *San Diego Union,* February 19, 1987,
sec. C, 5.

Reed, Victoria. "Traversing Borders: *Suspended
Text* and James Luna's *Selected Works* at Palomar
College." *Artweek* 22, no. 14 (April 11, 1991): 10.

Shere, Charles. "Castellon Gallery adds new
view." *Oakland Tribune,* August 20, 1981.

Jorge Pardo

Born in Havana, Cuba, 1963
Lives and works in Pasadena

Education

University of Illinois, Chicago, 1982–84
Art Center College of Design, Pasadena, B.F.A.,
1988

Individual Exhibitions

1988 Bliss Gallery, Pasadena
1990 Thomas Solomon's Garage,
 West Hollywood
 Petersburg Gallery, New York
1991 Luhring Augustine Hetzler, Santa Monica

Group Exhibitions

1987 Graduate Group Show, Art Center
 College Gallery, Pasadena
1989 H$_2$O, private residence, Beverly Hills
1990 Massimo Audiello Gallery, New York
 Jorge Pardo, Craig Watson, Terrain Gallery,
 San Francisco
 The Bradbury Building Show, The
 Bradbury Building, Los Angeles
 Luhring Augustine Hetzler, Santa Monica
1991 *L.A. Times,* Boise Museum of Modern
 Art, Boise, Idaho
 Improvements on the Ordinary, Randolph
 Street Gallery, Chicago
 Phenom/Phenotype: A Group Theory,
 Terrain Gallery, San Francisco
 O.M.D.G., Grace Cathedral,
 San Francisco

Bibliography

Brougher, Nora Halpern. "Jorge Pardo: Thomas
Solomon's Garage." *Flash Art* 23, no. 154 (October
1990): 156–57.

Knight, Christopher. "Review: Jorge Pardo."
Los Angeles Times, April 27, 1990.

Kornblau, Gary. "Jorge Pardo." *Art Issues,* no. 13
(September/October 1990): 35.

Sarah Seager

Born in Springfield, Massachusetts, 1958
Lives and works in Los Angeles

Education

University of California, Berkeley, B.F.A., 1982
University of California, Los Angeles, M.F.A.,
1987

Individual Exhibitions

1989 Dennis Anderson Gallery, Los Angeles
1991 Burnett Miller Gallery, Los Angeles
 Luhring Augustine Gallery, New York

Selected Group Exhibitions

1989 Dennis Anderson Gallery, Los Angeles
 Loaded, Richard Kuhlenschmidt Gallery,
 Santa Monica
 Asher/Faure Gallery, Los Angeles
1990 Galerie Schurr, Stuttgart
 Massimo Audiello, New York
 *Contingent Realms: Four Contemporary
 Sculptors,* Whitney Museum of American
 Art at Equitable Center, New York
 Fifth Anniversary Exhibition, Burnett
 Miller Gallery, Los Angeles
 Luhring Augustine Hetzler, Santa Monica
 Gallery Lelong, New York
1991 Interim Art, London

Bibliography

Anderson, Michael. "Sarah Seager at Dennis
Anderson." *Art in America* 77, no. 12 (December
1989): 183.

Brenson, Michael. "Contingent Realms: Four Contemporary Sculptors." *New York Times,* October 19, 1990, sec. B, 10.

Curtis, Cathy. "The Galleries." *Los Angeles Times,* August 12, 1989, sec. VI, 9.

Frank, Peter. "To Be Young, Gifted and Los Angeleno." *Visions Art Quarterly,* 10, no. 3 (Summer 1989): 24–28.

———. "Art Pick of the Week." *LA Weekly* 11, no. 39 (September 1–7, 1989): 118.

"Group Shows." *The New Yorker* 66, no. 22 (July 16, 1990): 13.

Hirsch, Jeffrey. "Work in Progress: A Portfolio of Emerging L.A. Artists." *L.A. Style* 6, no. 1 (June 1990): 186–99.

Knight, Christopher. "Group art shows bloom in August." *Los Angeles Herald Examiner,* August 11, 1989, sec. E, 40.

———. "L.A., Lately." *Elle* 5, no. 4 (December 1989): 190–92.

Smith, Roberta. "Group Show." *New York Times,* November 30, 1990.

Stephens, Richard. "Aspects of Our Corporeal Selves." *Artweek* 20, no. 27 (August 12, 1989): 3.

Weinberg, Adam D. *Contingent Realms: Four Contemporary Sculptors* (exh. cat.). New York: Whitney Museum of American Art at Equitable Center, 1990.

CHRISTOPHER WILLIAMS

Born in Los Angeles, 1956
Lives and works in Los Angeles

Education

California Institute of Arts, Valencia, B.F.A., 1979
California Institute of Arts, Valencia, M.F.A., 1981

Selected Individual Exhibitions

1982 Jancar/Kuhlenschmidt Gallery, Los Angeles
1985 Beyond Baroque Literary/Arts Center, Venice, California
1989 Galerie Crousel-Robelin Bama, Paris
 Luhring Augustine Gallery, New York
 Shedhalle, Zurich
1990 Luhring Augustine Hetzler, Santa Monica
1991 Galerie Max Hetzler, Cologne
 Galerie Crousel-Robelin Bama, Paris

Selected Group Exhibitions

1981 *5th International Biennale, Erweiterte Fotografie,* Weiner Secession, Vienna
1982 *74th American Exhibition,* The Art Institute of Chicago, Chicago
 Jancar/Kuhlenschmidt Gallery, Los Angeles
1983 *Unclaimed: 1 Pkg. Photos, 88 lbs., Identification Number 085-6595006* (in association with Mark Stahl), U.S. Customs, Terminal Island, California

1984 *Jenny Holzer, Stephen Prina, Mark Stahl, Christopher Williams,* De Appel Foundation, Amsterdam; Gewad, Ghent; Galerie Crousel-Hussenot, Paris (1985); Marian Goodman Gallery, New York (1985)
1985 *The Art of Memory, The Loss of History,* The New Museum of Contemporary Art, New York
1986 *TV Generations,* LACE (Los Angeles Contemporary Exhibitions)
 Rooted Rhetoric, Una Tradizione nell'Arte Americana, Castel dell'Ovo, Naples
 Mandelzomm, Castello di Vulci, Rome; De Appel Foundation, Amsterdam
1987 *Tim Ebner, John L. Grahm, Stephen Prina, Christopher Williams,* Kuhlenschmidt/Simon, Los Angeles
 Nothing Sacred, Margo Leavin Gallery, Los Angeles
 The Castle, Documenta 8, Kassel, West Germany
 CalArts: Skeptical Belief(s), The Renaissance Society at the University of Chicago, Chicago; Newport Harbor Art Museum, Newport Harbor, California (1988)
 L.A. Hot & Cool: the Eighties, List Visual Art Center, Massachusetts Institute of Technology, Cambridge
1988 *Material Ethics,* Milford Gallery, New York
 Galerie Crousel-Robelin Bama, Paris

1989 Robbin Lockett Gallery, Chicago
Materiality, CEPA, Buffalo
A Forest of Signs: Art in the Crisis of Representation, The Museum of Contemporary Art, Los Angeles
Wittgenstein and the Art of the 20th Century, Weiner Secession, Vienna, and Palais des Beaux Arts, Brussels
Galerie Ursula Schurr, Stuttgart
Constructing a History: A Focus on MOCA's Permanent Collection, The Museum of Contemporary Art, Los Angeles
Une Autre Affaire, Espace FRAC, Dijon, France

1990 *Prints and Multiples,* Luhring Augustine Hetzler, Santa Monica
Galerie Ursula Schurr, Stuttgart, Germany
Drawings, Luhring Augustine Hetzler, Santa Monica
Artedomani: 1990/Punto di Vista, Galleria Communale d'Arte Moderna, Spoleto, Italy
De Aftsand, Witte de With Center for Contemporary Art, Rotterdam, Holland
Vanitas, Galerie Crousel-Robelin Bama, Paris

1991 Galerie Samie Saouma, Paris
S. L. Simpson Gallery, Toronto

Selected Bibliography

Boehme, Marj. "Grahms's photo crashes gallery in Los Angeles." *News Review,* October 15, 1987.

Casorati, Cecelia, Cornelia Lauf and Tatjana Salzirn. *Artedomani: 1990/Punto di Vista* (exh. cat.). Rome: Incontri Internazionali d'Arte, 1990.

Chevrier, Jean-Francois. "Christopher Williams." In *De Afstand* (exh. cat.). Rotterdam: Witte de With Center for Contemporary Art, 1990.

Deitcher, David. "Angola to Vietnam: Unnatural Selection." *Visions Art Quarterly* 3, no. 1 (Winter 1988): 24–25.

Fehlau, Fred. "Tim Ebner, John L. Grahm, Stephen Prina, Christopher Williams." *Flash Art,* no. 137 (November/December 1987): 108–9.

Friis-Hansen, Dana. *LA Hot and Cool: The Eighties* (exh. cat.). Cambridge: MIT List Visual Arts Center, 1987, 28–29, 66.

Gardner, Colin. "Stephen Prina and Christopher Williams." *Artforum* 26 (December 1987) : 125–26.

———. "Christopher Williams at Luhring Augustine Hetzler." *Art Issues,* no. 16 (February/March 1991): 33.

Gibbs, Michael. "Deferral of Meaning." *De Appel* (Amsterdam), no. 1 (1985): 26–29.

Goldstein, Ann, Anne Rorimer, and Howard Singerman. *A Forest of Signs: Art in the Crisis of Representation* (exh. cat.). Los Angeles: The Museum of Contemporary Art, 1989.

Gookin, Kirby. " Christopher Williams at Luhring Augustine Gallery." *Artforum* 28, no. 1 (September 1989): 142.

———. "Constructing a History: Focus on MOCA's Permanent Collection" (exh. brochure). Los Angeles: The Museum of Contemporary Art, 1989.

Guercio, Gabriele. *Rooted Rhetoric, Una Tradizione nell' Arte Americana.* Naples: Guida editori, 1986.

Indiana, Gary. "Memories are Made of This." *The Village Voice* 30, no. 50 (December 10, 1985).

———. "Rooted Rhetoric: Castel dell'Oro [sic]." *Flash Art* no. 130 (October/November 1986): 84.

Olander, William, David Deitcher and Abigail Solomon-Godeau. *The Art of Memory, The Loss of History* (exh. cat.). New York: The New Museum of Contemporary Art, 1982.

Rorimer, Anne. *74th American Exhibition* (exh. cat.). Chicago: The Art Institute of Chicago, 1982.

van Bruggen, Coosje. *Jenny Holzer, Stephen Prina, Mark Stahl, Christopher Williams* (exh. cat.). Amsterdam: De Appel, 1984.

Weissman, Benjamin. "Christopher Williams' Dark Green Thumb." *Artforum* 28, no. 7 (March 1990): 132–36.

Williams, Christopher. *Angola to Vietnam.* Ghent: Imschoot, Uitgevers, 1989.

———. Artist supplement. *Artscribe International,* no. 84 (November/ December 1990): 63–71.

———. *Bouquet* (exh. cat.). Cologne: Galerie Max Hetzler, 1991.

———. "Jumbotron: The Largest Video Medium in History." In *TV Guides: a collection of thoughts about television,* edited by Barbara Kruger. Kuklapolitan Press, 1985.

MILLIE WILSON

Born in Hot Springs, Arkansas, 1948
Lives and works in Los Angeles

Education

University of Texas, Austin, B.F.A., 1971
University of Houston, M.F.A., 1983

Individual Exhibitions

1989 *Fauve Semblant: Peter (A Young English Girl),* Los Angeles Contemporary Exhibitions; San Francisco Camerawork Gallery (1990)
'Los Angeles Times' Series, University Art Gallery, State University of New York, Binghamton
1991 Meyers/Bloom Gallery, Los Angeles

Selected Group Exhibitions

1977 *Women in Sight,* Women & their Work/ Laguna Gloria Art Museum, Austin, Texas
1978 *Works on Paper: Southwest 1978,* Dallas Museum of Fine Arts
1980 *The Amarillo Competition,* The Amarillo Art Center, Texas
1981 *Longview Invitational,* Longview Museum and Art Center, Texas
1982 *Dream Show,* Dougherty Arts Center, Austin, Texas
1983 *Eleven Artists,* Blaffer Gallery, Houston
1984 *Discovery,* Lawndale Alternative, Houston
Introspectives, Pyramid Arts Center, Rochester, New York
1985 *Millie Wilson/Lisa Ginzel,* Contemporary Art Workshop, Chicago

1986 *Just 4,* Hyde Park Art Center, Chicago
1987 *Selections,* Diverse Works, Houston
1988 *Drawings by Ten,* Mandeville Gallery, University of California, San Diego
Omnibus Exhibition, Herron Gallery, Indianapolis
That's Progress, Beyond Baroque/LACPS (Los Angeles Center for Photographic Studies)
1989 *Thick and Thin: Photographically Inspired Paintings,* Fahey/Klein Gallery, Los Angeles
The Body You Want, Southern Exposure, San Francisco
Loaded, Richard Kuhlenschmidt Gallery, Los Angeles
Self/Evidence, LACE (Los Angeles Contemporary Exhibitions)
1990 *All But the Obvious,* LACE, Los Angeles
Post Boys and Girls, Artists Space, New York
Queer, Wessel O'Connor Ltd., New York
1991 *Gender and Representation,* Zoller Gallery, Pennsylvania State University, University Park, Pennsylvania
Making Sense, Bowman, Penelec and Megahen Galleries, Allegheny College, Meadville, Pennsylvania
Situation: Perspectives on Work by Lesbian and Gay Artists, New Langton Arts, San Francisco
Someone or Somebody, Meyers/Bloom Gallery, Los Angeles
(Dis)Member, Simon Watson, New York

Bibliography

Bonetti, David. "Explosions of gay, AIDS art." *San Francisco Examiner,* Friday, June 22, 1990, sec. C, 2.

——. "In search of a gay sensibility." *San Francisco Examiner,* June 25, 1991, sec. C., 1.

Curtis, Cathy. "LACE's 'Self-Evidence' Exhibit Takes Viewer for a Spin." *Los Angeles Times,* June 2, 1989.

——. "Galleries." *Los Angeles Times,* August 18, 1989.

Donohue, Marlena. "Galleries." *Los Angeles Times,* September 19, 1989.

Frank, Peter. "Los Angeles," *Contemporanea* 3, no. 6 (Summer 1990): 45.

Gilbert, Elizabeth. "Galleries." *Downtown Express,* September 17, 1990.

Gipe, Lawrence. "The Photograph as Verisimilitude: Millie Wilson and Doug Ischar at LACE." *Visions Art Quarterly* 4, no. 4 (Fall 1990): 22–23.

Grigsby, Darcy Grimaldo. "Dilemmas of Visibility: Contemporary Women Artists' Representations of Female Bodies." *Michigan Quarterly Review* 29, no. 4 (Fall 1990): 586–88.

Helfand, Glenn. "Liberating the Sexual Viewpoint." *Artweek* 20, no. 28 (August 26, 1989): 7.

Kandel, Susan. "L.A. in Review." *Arts* 65, no. 6 (February 1991): 110.

Knight, Christopher. "Loaded." *Los Angeles Herald Examiner,* August 4, 1989.

Kotz, Liz. "Images of Women." *Artweek* 21, no. 3 (January 25, 1990): 16.

———. "Guilty Objects, Unattainable Desires: The Body You Want." *Afterimage* 17, no. 6 (January 1990): cover, 12–14.

LaPalma, Marina. "A Painterly Reading of Photographed Imagery." *Artweek* 20, no. 31 (September 30, 1989): 4.

Lazzari, Margaret. "Contemplating the Self," *Artweek* 20, no. 21 (May 27, 1989): 5.

Oberlander, Wendy. "In the Gallery: 'Fauve Semblant: Peter (A Young English Girl).'" *SF Camerawork Quarterly* 17, no. 2 (Summer 1990): 28.

Raczka, Robert. "3rd Annual Critics' Picks: Ten Rising L.A. Artists." *LA Weekly* 11, no. 1 (December 9–15, 1988).

Rugoff, Ralph. "Body Doubles: Gender and its discontents." *LA Weekly* 13, no. 1 (December 7–13, 1990).

———. "Circumstantial Evidence." *LA Weekly* 11, no. 27 (June 9–15, 1989).

Stephens, Richard. "Aspects of Our Corporeal Selves," *Artweek* 20, no. 26 (August 12, 1989): 9.

Wilson, Millie. "Family." *Lucky,* no. 3 (Los Angeles, 1989): foldout.

———. "Fauve Semblant: Peter (A Young English Girl)" (exh. brochure). Los Angeles: LACE, 1989.

———. "The *Los Angeles Times* Series." *Exposure* 27, no. 1 (1989): 16–23.

———. *The Los Angeles Times Series* (exh. cat.). Binghamton, New York: State University of New York, 1989.

———. "She devised a retrospective for a fictitious lesbian artist…" *Framework* 3, nos. 2/3 (1990): 38–39.

———. Untitled. *Zyzzyva* 6, no. 2 (May 1990): 88–89.

———. Untitled. In *Dear World,* 18–19. San Francisco: Nayland Blake and Camille Roy, 1991.

Zellen, Jody. "Millie Wilson." *Art Issues,* no. 10 (March/April 1990): 26.

CHECKLIST

NAYLAND BLAKE

1. *Still Life,* 1991
SONY video 8 and steel; 8½ x 5 x 5 in. (21.6 x 12.7 x 12.7 cm); Collection of Robert Harshorn Shimshak, Berkeley.

2. *Transport #6,* 1991
Steel cable, aluminum, plastic, fabric, iron, and wood; dimensions variable, approx. 84 x 97 x 57 in. (213.4 x 246.4 x 144.8 cm); Courtesy of the artist and Mincher/Wilcox Gallery, San Francisco.

3. *Hybrid #2,* 1991
Deer antler, plastic, fabric, and steel; 26 x 19 x 11 in. (66 x 48.3 x 27.9 cm); Courtesy of the artist and Mincher/Wilcox Gallery, San Francisco.

4. *Magic,* 1990–91
Puppet, armature, box, and dried flowers; 36 x 6 x 9 in. (91.4 x 15.2 x 22.9 cm); Collection of Jay Gorney, New York.

JEROME CAJA

5. *Bozo Peeing on a Burning Bush,* 1987
Nail polish on metal tray; 7½ x 6½ x ½ in. (19.1 x 16.5 x 1.3 cm); Courtesy of the artist.

6. *Bozo Fucks Death,* 1988
Nail polish on plastic tray; 7½ x 5½ x ½ in. (19.1 x 14 x 1.3 cm); Collection of Rena McDonald aka Adam Klein, San Francisco.

7. *The Sunflower and the Daisy,* 1988
Nail polish on plastic tray; 7½ x 5½ x ½ in. (19.1 x 14 x 1.3 cm); Collection of Rena McDonald aka Adam Klein, San Francisco.

8. *Birth of the Egg/Birth of the Frying Pan,* 1989
Nail polish on metal card-case; 3¾ x 3¾ x 2 in. (9.5 x 9.5 x 5.1 cm) open; Courtesy of the artist.

9. *Dead Bird and Broken Egg,* 1989
Nail polish on metal ashtray; 4¾ in. (12.1 cm) diam. x ¼ in. (.6 cm); Courtesy of the artist.

10. *Eggs Having Turkey Dinner,* 1989
Nail polish on metal tip tray; 4¾ x 6¾ x ⅜ in. (12.1 x 17.1 x 1 cm); Collection of John and Bernardine Caja, Lakewood, Ohio.

11. *Cream of Clown Soup,* 1990
Nail polish, bottle cap, soup can, and tape; 8 x 5½ in. (20.3 x 14 cm); Collection of Travis Somerville and Nancy Carol King, San Francisco.

12. *Egg Ascending to Heaven,* 1990
Enamel, white-out, glitter, acrylic, and eyeliner on paper; 8¾ x 7 x ¼ in. (22.2 x 17.8 x .6 cm); Courtesy of the artist.

13. *Love Hold,* 1990
Enamel and tape on paper, mounted on leather; 6 x 5 in. (5.2 x 2.7 cm); Courtesy of the artist, San Francisco.

14. *Nine Bottlecaps,* 1990
Nail polish on bottle caps; assorted dimensions; Courtesy of the artist.

15. *Pompeii Salad,* 1990
Enamel, white-out, and nail polish on particle board; 5¾ x 6¾ x 1 in. (14.6 x 17.1 x 2.5 cm); Courtesy of the artist.

16. *Saint Theresa Bringing Flowers to the Damned,* 1990
Nail polish and glitter on canvas, twigs, fabric, and wood; 10¾ x 5½ x 3 in. (27.3 x 14 x 7.6 cm); Courtesy of the artist.

17. *The Black Purse,* 1990
Nail polish on sandpaper; 8 x 8 in. (20.3 x 20.3 cm); Collection of Christian Huygen, San Francisco.

18. *The Waiting Bird,* 1990
Enamel and eyeliner on paper; 8⅞ x 6⅞ x ¼ in. (22.5 x 17.5 x .6 cm); Courtesy of the artist.

19. *The White Sink,* 1990
White-out, nail polish, and eyeliner on paper; 8½ x 6½ in. (21.6 x 16.5 cm); Courtesy of the artist, San Francisco.

20. *Thirsty Birdy,* 1990
Enamel and gouache on paper; 10½ x 8⅛ x 1 in. (26.7 x 20.6 x 2.5 cm); Courtesy of the artist.

21. *Alice Jacking Off Her Jack Rabbit,* 1991
Watercolor and gouache on paper; 9⅝ x 11⅝ x 1¼ in. (24.5 x 29.5 x 3.2 cm); Courtesy of the artist.

22. *Amber,* 1991
Enamel, white-out, and gold leaf on paint-by-numbers paper; 13⅛ x 11⅛ x 1¾ in. (33.3 x 28.3 x 4.5 cm); Courtesy of the artist.

23. *Birdy Barbeque,* 1991
Gouache and watercolor on rice paper; 13¾ x 9¼ x ⅝ in. (34.9 x 23.5 x 1.6 cm); Courtesy of the artist.

24. *Fruit Bowl,* 1991
Watercolor, eyeliner, gouache, and white-out on paper; 8¼ x 7 x 1 in. (21 x 17.8 x 2.5 cm); Courtesy of the artist.

25. *Fruit Bowl from Above,* 1991
Enamel on paper; 10 x 8 x ⅞ in. (25.4 x 20.3 x 2.2 cm); Courtesy of the artist.

26. *Funeral for Jack-in-the-Box,* 1991
Watercolor and gouache on wood; 10¼ x 12¼ x 1¾ in. (26 x 31.1 x 4.5 cm); Courtesy of the artist.

27. *Ham and Eggs,* 1991
Enamel and gold leaf on paper; 12 x 6½ in. (30.5 x 16.5 cm); Courtesy of the artist.

28. *Hands Ascending to Heaven,* 1991
Enamel, eyeliner, and white-out on paper; 9½ x 7½ x ⅝ in. (24.1 x 19.1 x 1.6 cm); Courtesy of the artist.

29. *Heart and Barf,* 1991
Enamel on paper; 8¼ x 6½ x ½ in. (21 x 16.5 x 1.3 cm); Courtesy of the artist.

30. *Lovebirds at McDonald's,* 1991
Enamel and white-out on paper; 8 x 7¼ x 1 in. (20.3 x 18.4 x 2.5 cm); Courtesy of the artist.

31. *Mini-shroud for Bozo,* 1991
Watercolor and gouache on Band-aid; 8 x 5½ x 1¼ in. (20.3 x 14 x 3.2 cm); Courtesy of the artist.

32. *Mona Lisa,* 1991
Bottle cap, nail polish, and gold leaf on plate, metal; 4½ in. (11.4 cm) diam. x 3 in. (7.6 cm); Courtesy of the artist.

33. *Mr. Peanut Ascending to Heaven,* 1991
Enamel and nail polish on paper; 5⅞ x 4⅞ x 1 in. (14.9 x 12.4 x 2.5 cm); Courtesy of the artist.

34. *Sacred Heart Potholder,* 1991
Nail polish and gold leaf on potholder; 12½ x 11 in. (31.8 x 27.9 cm); Courtesy of the artist.

35. *Safe Banana Ascending,* 1991
Nail polish, eyeliner, enamel, and white-out on paper; 4 x 3⅝ x ½ in (10.2 x 9.2 x 1.3 cm); Courtesy of the artist.

36. *Saint Sebastian and His Bluebird of Happiness,* 1991
Nail polish on tar paper; 6½ x 3 in. (16.5 x 7.6 cm); Courtesy of the artist.

37. *Salvation of the Fruit Bowl,* 1991
Watercolor and gouache on paper; 13⅝ x 11⅝ x 1 in. (34.6 x 29.5 x 2.5 cm); Courtesy of the artist.

38. *Sofa-Sized Painting,* 1991
Gouache on paper, 10¼ x 8⅛ x 1 in. (26 x 20.6 x 2.5 cm); Courtesy of the artist.

39. *The Foot of Christ,* 1991
Nail polish on toe nails; 4 x 3⅝ x ½ in. (10.2 x 9.2 x 1.3 cm); Courtesy of the artist.

40. *The Holy Spirit Getting New Eyes from Saint Lucy,* 1991
Enamel, pencil, and china marker on paper; 11½ x 9½ x 1¼ in. (29.2 x 24.1 x 3.2 cm); Courtesy of the artist.

41. *The Safe Birdhouse,* 1991
Watercolor and gouache on paper; 9 x 7 in. (22.9 x 17.8 cm); Courtesy of the artist.

42. *The Wishbone,* 1991
Nail polish, eyeliner, enamel, and pencil on paper; 9⅜ x 11¾ x ½ in. (23.8 x 29.8 x 1.3 cm); Courtesy of the artist.

JIM CAMPBELL

43. *Memory/Recollection,* 1990
5 picture tubes, live camera, 286 computer with hard disk; 54 x 36 x 12 in. (137.2 x 91.4 x 30.5 cm); Collection of Roselyne and Richard Swig, San Francisco.

44. *Digital Watch,* 1991
50″ video monitor, custom electronics, two video cameras; installation dimensions variable; Courtesy of the artist and Rena Bransten Gallery, San Francisco.

45. *Light,* 1991
Live camera, computer, video monitor, and candle; 24 x 36 x 36 in. (61 x 91.4 x 91.4 cm); Courtesy of the artist.

DAVID KREMERS

46. $^{230}_{88}Ra$ *(93m),* from the *Chemical Isotope* series, 1989
Decayed oil on wood; 48 x 48 x ¾ in. (121.9 x 121.9 x 1.9 cm); Private collection.

47. $^{228}_{88}Ra$ *(5.76 years),* from the *Chemical Isotope* series, 1990
Decayed oil on wood; 48 x 48 x ¾ in. (121.9 x 121.9 x 1.9 cm); Courtesy of the artist and Thomas Solomon's Garage, Los Angeles.

48. Untitled, from the *Sun on Paper* series, 1989
Sun on paper, mounted on steel; 72 x 54 in. (182.9 x 137.2 cm); Private collection.

49. *sin ⌀,* 1991
Gesso and chaos on ash veneer; 48 x 48 in. (121.9 x 121.9 cm); Private collection.

50. *Untitled,* from the *Sun on Paper* series, 1991
Sun on paper; 144 x 108 in. (365.8 x 274.3 cm); Courtesy of the artist.

RACHEL LACHOWICZ

51. *Charcoal on Paper,* 1989
Wood and paper; 2 parts: 44 x 53 x 34 in. (111.8 x 134.6 x 86.4 cm) and 72 x 180 in. (182.9 x 457.2 cm); Collection of Morris and Ellen Grabie, Los Angeles.

52. *Collagen,* 1990
Cast lipstick; 3 in. x 16 ft. x ¼ in. (7.6 x 487.7 x .6 cm); Courtesy Shoshana Wayne Gallery, Santa Monica.

53. *Lipstick Cube,* 1990
Cast lipstick; 8 x 8 x 8 in. (20.3 x 20.3 x 20.3 cm); Collection of Eileen and Michael Cohen, New York

54. *Third String,* 1990
Violins, shoes, violin parts; 106½ x 36 x 10 in. (270.5 x 91.4 x 25.4 cm); The Rene and Veronica di Rosa Foundation, Napa.

55. *Homage to Carl André,* 1991
(after Carl André's *Magnesium and Zinc,* 1969)
Cast lipstick; ⅜ x 72 x 72 in. (1 x 182.9 x 182.9 cm); Courtesy Shoshana Wayne Gallery, Santa Monica.

JAMES LUNA

56. *AA Meeting/Art History,* 1990–91
6 photographs, videotape, chairs, stool, ashtrays, used coffee cups, 2 beer bottles, and AA book; installation dimensions variable; Courtesy of the artist.
Art History series (photos by Richard Lou):
 The Thinker, 1990
 Gelatin silver print; 30 x 39¹⁵⁄₁₆ (76.2 x 101.4 cm)
 Guernica, 1990
 4 gelatin silver prints; 14 x 20 in. (35.6 x 50.8 cm); 20 x 16 in. (50.8 x 40.6 cm); 20 x 15¾ in. (50.8 x 40 cm); 20 x 15⅞ in. (50.8 x 40.3 cm)
 The End of the Trail, 1990
 Gelatin silver print; 30 x 39¹⁵⁄₁₆ (76.2 x 101.4 cm)

57. *Wake/Velorio (He's Resting Now),* 1985
Chairs, clothes, shoes, purses, ashtrays, cups, cigarettes, tin cans, abalone bowl, sage, rattles, cowboy hat, boots, and black cloth; installation dimensions variable; Courtesy of the artist.

JORGE PARDO

58. *David Alper and Susan Stein's Cabinet, 516 18th St., Santa Monica,* 1990
Fir plywood, drawer slides, blue paint dye, cabinet staples, and wood screws; as installed: 80¾ x 81 x 29 in. (205.1 x 205.7 x 73.7 cm); Courtesy Luhring Augustine Hetzler, Santa Monica.

59. *Herbert Matter Painting (Diptych), Arts and Architecture September 1946, page 40 & 41,* 1991
Maple, plexiglass, glass, drafting tape, tracing paper, and magazine pages; 2 parts: 27 x 21 x 2⅛ in. (68.6 x 53.3 x 5.4 cm) each; Courtesy Terrain, San Francisco.

60. *K-Mart Painting,* 1991
Chromatec, Canson paper, Standard Brand Premium Latex flat paint, maple, plexiglass, and artifact by Ucef Hanjani; 2 parts: 34½ x 53¼ x 2¼ in. (87.6 x 137.8 x 5.7 cm) and 16¼ x 18¾ x ¼ in. (41.3 x 47.6 x .6 cm); Courtesy Terrain, San Francisco; artifact, collection of the artist.

61. *McDonald's Nail Dryer,* 1991
Plastic, nail dryer, lacquer, and Chromatec; 5 x 7 in. (12.7 x 17.8 cm) diam.; Courtesy Luhring Augustine Hetzler, Santa Monica.

62. *Painting for Page 24 of the J. Crew Catalogue (Spring) / Painting that Takes Issue with Six Rectangles on Page 80 of the J. Crew Catalogue (Spring),* 1991
2 parts: circular piece: maple, plexiglass, foamcore, house paint, color xerox, drywall screws; 21 in. (53.3 cm) diam.; rectangular piece: particle board, plexiglass, foamcore, house paint, color xerox, drywall screws; 60 x 40 in. (152.4 x 101.6 cm); Courtesy Luhring Augustine Hetzler, Santa Monica.

Sarah Seager

63. *SING,* 1989
Fluorescent lights and enamel sign paint; 8 in. by
16 ft. by 1 in (20.3 x 487.7 x 2.5 cm); Lockhart
Collection, New York.

64. *White Rail,* 1990
Enamel paint on steel; 4½ x 133 x 3½ in. (11.4 x
337.8 x 8.9 cm); Collection of Robert Lue,
Boston.

65. Untitled (Birds), 1991
Enamel on canvas; 96 x 68 x 1¼ in. (243.8 x 172.7
x 3.2 cm); Collection of Pablo and Leslie Lawner,
Los Angeles.

66. *Untitled Other,* 1991
Wood, glass, and plexiglass; 2 parts: 86 x 33¾ x
33¾ in. (218.4 x 85.7 x 85.7 cm) each; Private
collection, courtesy Jeffrey Deitch.

67. Untitled (ta ta te), 1991
Enamel on canvas; 68 x 96 x 1¼ in. (172.7 x 243.8
x 3.2 cm); Courtesy Burnett Miller Gallery,
Los Angeles.

Christopher Williams

68. *Brasil,* 1989
Front cover, *Elle* magazine, August 15, 1988, EDI
7, France Editions et Publications S.A., Neuilly-
sur-Seine, France, six-color web offset printing on
machine coated paper; 11⅝ x 9 in. (29.7 x 22.7
cm); Private collection, Los Angeles.

69. *Angola to Vietnam,* 1989
27 gelatin silver prints; 11 x 14 in. (27.9 x 35.6 cm)
each; Courtesy Luhring Augustine Gallery,
New York.

Millie Wilson

70. *Her Last Palette,* from the installation *Fauve
Semblant: Peter (A Young English Girl),* 1989
Gelatin silver print, wood, plexiglass, and brass
label plate; 36⅞ x 28⅞ x 3¼ in. (93.7 x 73.3 x
8.3 cm) plus label: 1¾ x 8 in. (4.5 x 20.3 cm);
Courtesy Meyers/Bloom Gallery and the artist.

71. *Leotard/Cheater/Painter,* from the installation
Fauve Semblant: Peter (A Young English Girl), 1989
Fabric, gelatin silver print, acrylic on canvas,
wood, plexiglass, text panel, and vinyl type; 4
parts: 3 at 26¾ x 26¾ in (68 x 68 cm), 1 at 14 x 9
in. (35.6.x 48.3 cm); Courtesy Meyers/Bloom
Gallery and the artist.

72. *Bulldagger/Painter,* from the installation *Fauve
Semblant: Peter (A Young English Girl),* 1989
Framed mirror, text panel, latex paint, and vinyl
type on plexiglass; installation dimensions
variable; Courtesy Meyers/Bloom Gallery and
the artist.

73. *Disturbances,* from *The Museum of Lesbian
Dreams,* 1990
9 framed gelatin silver prints, dye, and silkscreen;
installation dimensions variable; Courtesy
Meyers/Bloom Gallery and the artist; Funded
in part by a grant from LACE/Los Angeles
Contemporary Exhibitions, through the
Rockefeller Foundation and the Inter-Arts
Program of the National Endowment for the
Arts, and a grant from Art Matters, Inc.

74. *Wig,* from *The Museum of Lesbian Dreams,* 1990
Wig, mahogany, glass, gelatin silver prints,
chrome; installation in 3 parts: pedestal and vitrine
78 x 75 x 30 in. (198.1 x 190.5 x 76.2 cm) plus 2
small framed drawings, 15¾ x 20 ⅜ in. (40 x 51.8
cm) each; Courtesy Meyers/Bloom Gallery and
the artist; Funded in part by a grant from LACE/
Los Angeles Contemporary Exhibitions, through
the Rockefeller Foundation and the Inter-Arts
Program of the National Endowment for the
Arts, and a grant from Art Matters, Inc.

75. *Faute de Mieux,* (For lack of anything better)
from *The Museum of Lesbian Dreams,* 1991
Quartz, wood, plexiglass, formica, velvet, brass
hardware and label plate; 42¼ x 28 x 25 in. (107.3
x 71.1 x 63.5 cm); Courtesy Meyers/Bloom
Gallery and the artist; Funded in part by a grant
from LACE/Los Angeles Contemporary
Exhibitions, through the Rockefeller Foundation
and the Inter-Arts Program of the National
Endowment for the Arts, and a grant from Art
Matters, Inc.

76. *Language of Dreams,* from *The Museum of
Lesbian Dreams,* 1991
Wood, latex paint, steel, and plexiglass; 42¼ x 28
x 25 in. (107.3 x 71.1 x 63.5 cm); Courtesy of
Meyers/Bloom Gallery and the artist; Funded in
part by a grant from LACE/Los Angeles
Contemporary Exhibitions, through the
Rockefeller Foundation and the Inter-Arts
Program of the National Endowment for the
Arts, and a grant from Art Matters, Inc.

CONTEMPORARY ART

The concept of the Fellows of Contemporary Art as developed by its founding members is unique. We are an independent organization established in 1975. Monies received from dues are used to underwrite our exhibitions, catalogues, and videos at tax-exempt museums and galleries that have their focus in the field of contemporary art. We do not give grants, sponsor fund-raising events, or maintain a permanent facility or collection. In addition to the exhibition schedule, the Fellows have an active membership education program.

EXHIBITIONS

1976

Ed Moses Drawings 1958–1976
Frederick S. Wight Art Gallery
University of California, Los Angeles
July 13–August 15, 1976
Catalogue with essay by Joseph Masheck

1977

Unstretched Surfaces/Surfaces Libres
Los Angeles Institute of Contemporary Art
November 5–December 16, 1977
Catalogue with essays by Jean-Luc Bordeaux, Alfred Pacquement, Pontus Hulten. Artists: Bernadette Bour, Jerrold Burchman, Thierry Delaroyere, Daniel Dezeuze, Charles Christopher Hill, Christian Jaccard, Allan McCollum, Jean-Michel Meurice, Jean-Pierre Pincemin, Peter Plagens, Tom Wudl, Richard Yokomi

1978–80

Wallace Berman Retrospective
Otis Art Institute Gallery, Los Angeles
October 24–November 25, 1978
Catalogue with essays by Robert Duncan and David Meltzer. The exhibition was supported by a grant from the National Endowment for the Arts, Washington, D.C., a Federal agency. Exhibition tour: Fort Worth Art Museum, Texas; University Art Museum, University of California, Berkeley; Seattle Art Museum

1979–80

Vija Celmins, a Survey Exhibition
Newport Harbor Art Museum, Newport Beach
December 15, 1979–February 3, 1980
Catalogue with essay by Susan C. Larsen. The exhibition was supported by a grant from the National Endowment for the Arts, Washington, D.C., a Federal agency. Exhibition tour: The Arts Club of Chicago; The Hudson River Museum, Yonkers, New York; The Corcoran Gallery of Art, Washington, D.C.

1980

Variations: Five Los Angeles Painters
University Art Galleries
University of Southern California, Los Angeles
October 20–November 23, 1980
Catalogue with essay by Susan C. Larsen. Artists: Robert Ackerman, Ed Gilliam, George Rodart, Don Suggs, Norton Wisdom

1981–82

Craig Kauffman Comprehensive Survey 1957–1980
La Jolla Museum of Contemporary Art
March 14–May 3, 1981
Catalogue with essay by Robert McDonald. The exhibition was supported by a grant from the National Endowment for the Arts, Washington, D.C., a Federal agency. Exhibition tour: Elvehjem Museum of Art, University of Wisconsin, Madison; Anderson Gallery, Virginia Commonwealth University, Richmond; The Oakland Museum

1981–82

Paul Wonner: Abstract Realist
San Francisco Museum of Modern Art
October 1–November 22, 1981
Catalogue with essay by George W. Neubert. Exhibition tour: Marion Koogler McNay Art Institute, San Antonio, Texas; Los Angeles Municipal Art Gallery

1982–83

Changing Trends: Content and Style
Twelve Southern California Painters
Laguna Beach Museum of Art
November 18, 1982–January 3, 1983
Catalogue with essays by Francis Colpitt, Christopher Knight, Peter Plagens, Robert Smith. Exhibition tour: Los Angeles Institute of Contemporary Art. Artists: Robert Ackerman, Caron Colvin, Scott Grieger, Marvin Harden, James Hayward, Ron Linden, John Miller, Pierre Picot, George Rodart, Don Suggs, David Trowbridge, Tom Wudl

1983

Variations II: Seven Los Angeles Painters
Gallery at the Plaza
Security Pacific National Bank, Los Angeles
May 8–June 30, 1983
Catalogue with essay by Constance Mallinson. Artists: Roy Dowell, Kim Hubbard, David Lawson, William Mahan, Janet McCloud, Richard Sedivy, Hye Sook

1984

Martha Alf Retrospective
Los Angeles Municipal Art Gallery
March 6–April 1, 1984
Catalogue with essay by Suzanne Muchnic. Exhibition tour: The Walter/McBean Galleries, San Francisco Art Institute

1985

Sunshine and Shadow: Recent Painting in Southern California
Fisher Gallery
University of Southern California, Los Angeles
January 15–February 23, 1985
Catalogue with essay by Susan C. Larsen. Artists: Robert Ackerman, Richard Baker, William Brice, Karen Carson, Lois Colette, Ronald Davis, Richard Diebenkorn, John Eden, Llyn Foulkes, Charles Garabedian, Candice Gawne, Joe Goode, James Hayward, Roger Herman, Charles Christopher Hill, Craig Kauffman, Gary Lang, Dan McCleary, Arnold Mesches, John M. Miller, Ed Moses, Margit Omar, Marc Pally, Pierre Picot, Peter Plagens, Luis Serrano, Reesey Shaw, Ernest Silva, Tom Wudl

1985–86

James Turrell
The Museum of Contemporary Art, Los Angeles
November 13, 1985–February 9, 1986
A book entitled *Occluded Front: James Turrell* was published in conjunction with the exhibition.

1986

William Brice
The Museum of Contemporary Art, Los Angeles
September 1–October 19, 1986
Full-color catalogue with essay by Richard Armstrong. Exhibition tour: Grey Art Gallery and Study Center, New York University, New York

1987

Variations III: Emerging Artists in Southern California
Los Angeles Contemporary Exhibitions, Los Angeles
April 22–May 31, 1987
Catalogue with essay by Melinda Wortz. Exhibition tour: Fine Arts Gallery, University of California, Irvine; Art Gallery, California State University, Northridge. Artists: Alvaro Asturias/John Castagna, Hildegarde Duane/David Lamelas, Tom Knechtel, Joyce Lightbody, Julie Medwedeff, Ihnsoon Nam, Ed Nunnery, Patti Podesta, Deborah Small, Rena Small, Linda Ann Stark

1987–88

Perpetual Motion
Santa Barbara Museum of Art
November 17, 1987–January 24, 1988
Catalogue with essay by Betty Turnbull. Artists:
Karen Carson, Margaret Nielsen, John Rogers,
Tom Wudl

1988

Jud Fine
La Jolla Museum of Contemporary Art
August 19–October 2, 1988
Catalogue with essays by Ronald J. Onorato and
Madeleine Grynstejn. Video produced and
directed by Joe Leonardi and Cathleen Kane, Long
Beach Museum of Art Video Annex. Exhibition
tour: de Saisset Museum, Santa Clara University,
California

1989–90

The Pasadena Armory Show 1989
The Armory Center for the Arts, Pasadena
November 2, 1989–January 31, 1990
Catalogue with essay by Dave Hickey and
curatorial statement by Noel Korten. Video
produced and directed by Joe Leonardi, Long
Beach Museum of Art Video Annex. Artists:
Carole Caroompas, Karen Carsen, Michael Davis,
James Doolin, Scott Grieger, Raul Guerrero,
William Leavitt, Jerry McMillan, Michael C.
McMillen, Margit Omar, John Outterbridge,
Ann Page, John Valadez

1990

Lita Albuquerque: Reflections
Santa Monica Museum of Art
January 19–April 1, 1990
Catalogue with essay by Jan Butterfield and
interview with Lita Albuquerque by the curator,
Henry Hopkins. Video produced and directed by
Joe Leonardi, Long Beach Museum of Art Video
Annex

Video Series

Videos are produced and directed by Joe Leonardi,
Long Beach Museum of Art Video Annex, for the
Fellows of Contemporary Art.
Red is Green: Jud Fine, 1988
Horace Bristol: Photojournalist, 1989
*Altering Discourse: The Works of Helen and Newton
 Harrison,* 1989
Frame and Context: Richard Ross, 1989
*Experience: Perception, Interpretation, Illusion (The
 Pasadena Armory Show 1989),* 1989
*Secrets, Dialogs, Revelations: The Art of Betye and
 Alison Saar,* 1990
Lita Albuquerque: Reflections, 1990
Los Angeles Murals, 1990
Stretching the Canvas, Compilation tape narrated
 by Peter Sellars, 1990
Michael Todd: Jazz, 1990

Mr. and Mrs. William H. Hurt
Mr. and Mrs. Jerome Janger
Mr. and Mrs. Lambert M. Javelera
Mr. and Mrs. E. Eric Johnson
Mr. and Mrs. Jerry W. Johnston
Mr. and Mrs. Solomon M. Kamm
Mr. and Mrs. Robert Keilly
Mr. and Mrs. John C. Kennady
Ms. Virginia C. Krueger
Mr. and Mrs. Russel I. Kully
Dr. and Mrs. Gerald W. Labiner
Mr. and Mrs. Sidney Landis
Mr. and Mrs. Nahum Lainer
Dr. and Mrs. Eldridge L. Lasell
Mr. and Mrs. Hoyt Leisure
Mr. and Mrs. Charles M. Levy
Linda L. Lund
Dr. and Mrs. John E. Lusche
Mr. and Mrs. Leon Lyon
Mr. and Mrs. Vincent J. McGuinness
Mr. and Mrs. James McIntyre
Mr. and Mrs. Frederick McLane
Sylvia Mandigo
Mr. and Mrs. Brian L. Manning
Mr. and Mrs. Robert T. Martinet, Jr.
Hon. and Mrs. William Masterson
Mr. and Mrs. J. Terry Maxwell
Mr. and Mrs. Philip H. Meltzer
Mr. and Mrs. Walter Meyer
Ms. Jeanne Meyers
Mrs. Alathena Miller
Mr. and Mrs. Charles D. Miller
Mr. Gavin Miller
Mr. and Mrs. Clinton W. Mills
Mr. D. Harry Montgomery
Anne Marie Moses
Sally E. Mosher

Mr. and Mrs. George Nagler
Dr. and Mrs. Robert M. Newhouse
Dr. and Mrs. Richard E. Newquist
Mr. and Mrs. Frederick M. Nicholas
Mr. and Mrs. James W. Obrien
Dr. and Mrs. Giuseppe Panza di Biumo
Mr. and Mrs. David B. Partridge
Mr. and Mrs. Theodore Paulson
Ms. Joan A. Payden
Mr. and Mrs. J. Blair Pence II
Mr. and Mrs. Standish K. Penton
Mr. and Mrs. Frank H. Person
Peggy Phelps
Dr. and Mrs. Reese Polesky
Mr. and Mrs. M.B. Preeman
Mr. and Mrs. David Price
Mr. and Mrs. Lawrence J. Ramer
Mr. and Mrs. Charles C. Read
Kathleen Reges and Richard Carlson
Mrs. Joan B. Rehnborg
Mr. and Mrs. Bernard Ridder, Jr.
Mr. and Mrs. Chapin Riley
Dr. and Mrs. Armin Sadoff
Ms. Ramona A. Sahm
Mr. and Mrs. Barry A. Sanders
Mr. and Mrs. Fred Schoellkopf
Mrs. June W. Schuster
Mr. and Mrs. J.C. Schwarzenbach
Mr. and Mrs. David C. Seager III
Dr. and Mrs. Garland Sinow
Mr. and Mrs. George Smith
Mr. and Mrs. Russell Dymock Smith
Mr. and Mrs. Howard Smits
Mr. William R. Solaini
Mr. and Mrs. Milton R. Stark
Ms. Laurie Smits Staude
Mr. and Mrs. David H. Steinmetz

Mr. and Mrs. Goerge E. Stephens, Jr.
Mr. and Mrs. Jason H. Stevens
Mr. and Mrs. Richard L. Stever
Joan Stewart
Elaine Stone
Mrs. Ann E. Summers
Mr. and Mrs. Robert M. Talcott
Mr. and Mrs. Dennis Tani
Mr. and Mrs. Stanford H. Taylor
Dr. and Mrs. Don Thomas
Mr. and Mrs. Joseph Tom
Mr. and Mrs. Erwin Tomash
Mr. and Mrs. James R. Ukropina
Jolly Urner
Mr. and Mrs. Robert D. Volk
Mr. and Mrs. Frederick R. Waingrow
Corinne Whitaker and Michael Sheedy
Mr. and Mrs. George F. Wick
Mr. and Mrs. Toby Franklin K. Wilcox
Mrs. James Williams Wild
Mr. and Mrs. John H. Wilke
Mr. and Mrs. Richard A. Wilson
Mr. and Mrs. Eric Wittenberg
Mr. and Mrs. Robert J. Woods, Jr.
Mr. and Mrs. Paul K. Yost III
Mrs. Billie K. Youngblood